MARKET HARBOROUGH

AND THE LOCAL VILLAGES

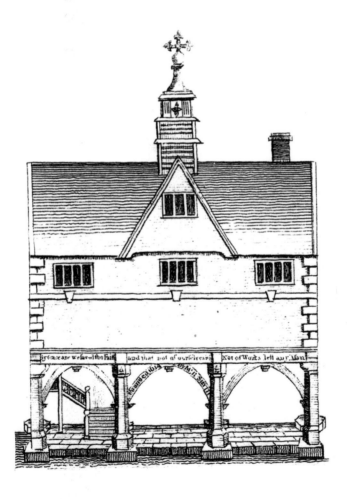

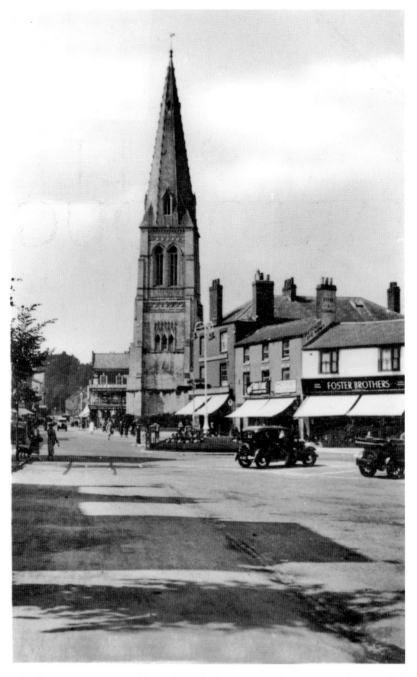

The church of St Dionysius, possibly built in the late thirteenth century and certainly by 1300. The steeple is considered to be one of the finest in England. This splendid spire can be viewed from most parts of the town and is incorporated in many photographs printed in this book. The vicar in 1932 was Revd Osborne St Maur Williams MH. This market town was created in 1176-77 at a crossing over the Welland River, as trade expanded throughout the country.

Featured in this photograph is Foster Brothers' Clothing Ltd, trading as a clothier on 11-12 The Square. In this area a market was held from the late twelfth century.

MARKET HARBOROUGH
AND THE LOCAL VILLAGES

TREVOR HICKMAN

AMBERLEY

A typical view, north of Market Harborough,
in the eighteenth century.
Wood engraving by Thomas Bewick.

First published 2011

Amberley Publishing
Cirencester Road, Chalford,
Stroud, Gloucestershire, GL6 8PE

www.amberleybooks.com

British Library Cataloguing in Publication Data.
A catalogue record for this book is available from the British Library.

ISBN 978-1-4456-0393-3

Typeset in 10pt on 12pt Sabon.
Typesetting and Origination by Amberley Publishing.
Printed in the UK.

CONTENTS

INTRODUCTION

I have always been interested in market towns and Market Harborough is no exception. Even though it is a modern town, it has maintained much of its historic character. I consider it to be a delightful town to walk around, especially when a farmers' market

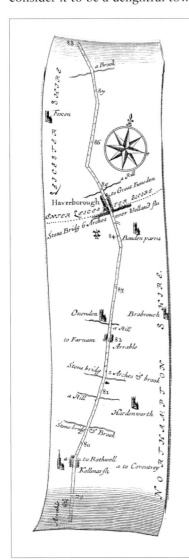

is being held on The Square. There is still a fine selection of shops, and there are some excellent bars, restaurants and speciality eating houses. Changes do take place, and this is essential to maintain a position as a thriving town in the twenty-first century. This is a personal selection involving photographs and illustrations that I have selected from my own collection of historic images and should not be considered a history of Market Harborough; it is a compilation of interesting images that I consider to be of a historical nature and that should be considered alongside other fine publications covering this market town. Local history is the clear intention; occasionally I have used very modern photographs to enhance my research and occasionally twenty-first-century photographs are published with nineteenth-century images of the same location.

This book was compiled with the help of my granddaughter Amy Grech. We have travelled together visiting the thirty-eight villages and the market town featured in this book. We have visited every church featured, although many were locked. Wherever possible we entered the building, and much of what we saw has been recorded here.

The London to Leicester road, through 'Haverborough' (Market Harborough). A strip map from John Ogilby's *Britannia* of 1675.

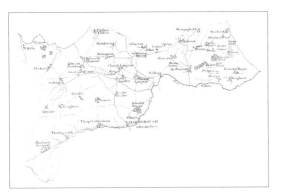 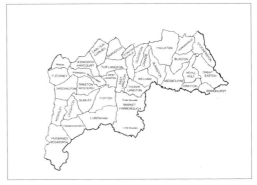

Above left: The southern part of a map recording the Gartre Hundred, from John Cary's map of 1798. The town of Harborough and the villages of Bowden Parva (Little Bowden) and Bowden Magna (Great Bowden).

Above right: A modern plan of the villages and parishes that are located in the southern area of Harborough District Council. All those listed above are included in this book.

It is not possible to record which parish is the most interesting, and there are many surprises! To me, as an author who is interested in local history, the mud wall with a thatched cap that has been preserved in front of the church of St Luke at Laughton is one of the most interesting features I met on my journey around the area in south Leicestershire. Then of course there is Foxton Locks, completed in 1812 on the Grand Union Canal and known as 'a staircase of locks'.

Walk around Market Harborough on a shopping expedition – then step back in front of some of the shops in the centre of the town. The Victorian features have still been maintained, and very few photographs from that period exist. In this book I have included a large collection of advertisements involving businesses operating in the 1850s through to the 1930s. I consider this to be a very important record.

South of the River Welland is the district of Little Bowden, a separate village situated in Northamptonshire until national boundary changes were instigated in the local government act of 1894. In 1927 a confirmation order was passed, and the three parishes of Market Harborough, Little Bowden and Great Bowden were amalgamated to form the parish of Market Harborough.

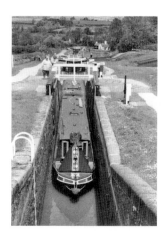
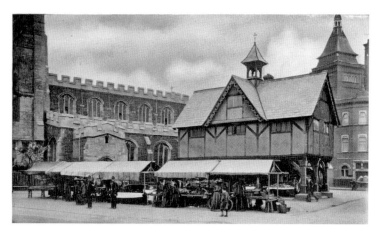

Above left: The 'staircase' of locks at Foxton, 2002. A barge is 'climbing the stairs'.

Above right: Robert Smyth's Grammar School, built in 1614, with sturdy posts and braces to serve as an indoor market. In this photograph, taken in 1905, stalls have been erected under the building, in The Square, and some overlap into Church Square.

I have divided this book into six chapters, commencing with 'Off "The Grand Union"'. Eleven parishes have been visited and the collection contains historic and modern photographs, engravings and drawings. In this presentation one of the largest villages is Fleckney, where an old friend, Jack Badcock, lived. We met in 1970 and through him I was introduced into the south Leicestershire countryside as a naturalist, artist and author. There is very little he did not know about his county. In the second chapter, 'Market Harborough District', I have devoted over eighty pages to cover this very interesting market town. The third chapter is 'Around "The Langtons"'. In 1980 Canon John Prophet approached me to help him compile a book about William Hambury, the eighteenth-century visionary who was the vicar at Church Langton. With the help of John Prophet I was introduced into the Langtons, its churches and public houses. The final chapter is 'Out to "Eye Brook"', based on the district of the Fernie Hunt. Fox hunting is a controversial subject; unquestionably it is part of countryside history and folklore. In the 1880s Nevill Holt was the centre of fox hunting with national interest. On the county border is Eye Brook reservoir, and the border lies through the centre of the lake. It holds its place in history as one of the expanses of water used in Great Britain to train pilots in the Second World War to bomb the dams in Germany.

OFF 'THE GRAND UNION'

The bridge across the arm of the Grand Union Canal, leading from Foxton Locks into the Market Harborough canal basin, *c.* 1905.

A major tourist attraction is Foxton Locks on the Grand Union Canal. When barges are travelling up or down the locks it is a fine experience. In the basin at the foot of the flight is Foxton Boat Services. To walk along the footpaths surrounding this site is a step back in time. To be conveyed to this historic development and then walk back to Market Harborough, through some interesting countryside during the summer months, is a wonderful experience.

The Grand Union Canal passes through the parishes of Fleckney and the Saddington Tunnel with Gumley to the west and Foxton to the east, with the staircase of locks between the two villages. Laughton Hills offers excellent fox-hunting country, where the Fernie Hunt have had some great chases, and although the law has changed, riding horses across challenging fences on an autumn morning is still a very fine historic sight.

WISTOW

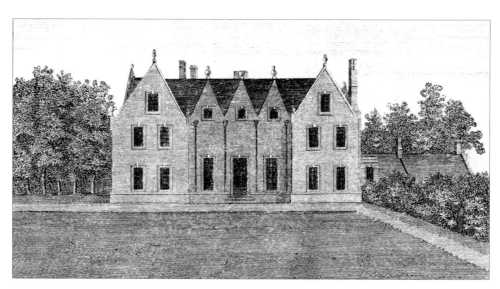

An engraving published in 1798 of Wistow Hall, the home of James Vaughan, probably built about 1603 on the site of a much earlier house. Charles I is said to have visited this hall in 1645 on the way to the battle at Naseby and to have stayed at the hall again on his way to Oxford, having lost the famous battle. The home was that of Richard Halford, who had been created a baronet by Charles I in 1641.

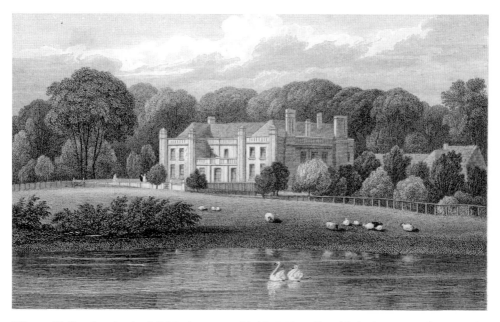

Wistow Hall, a drawing by J. P. Neale engraved by J. C. Varrall, published on 1 October 1821 by Sherwood, Neely & Jones, who traded out of Paternoster Row, London. Considerable alterations were made to the house by Sir Henry Haford in 1814.

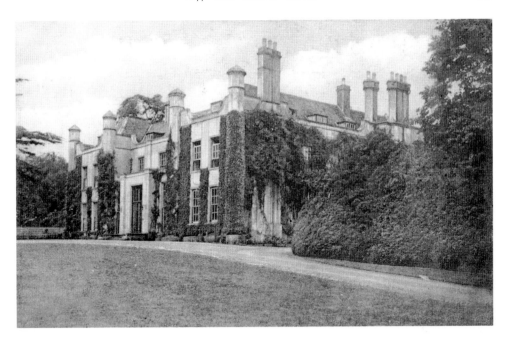

Wistow Hall, *c.* 1910.

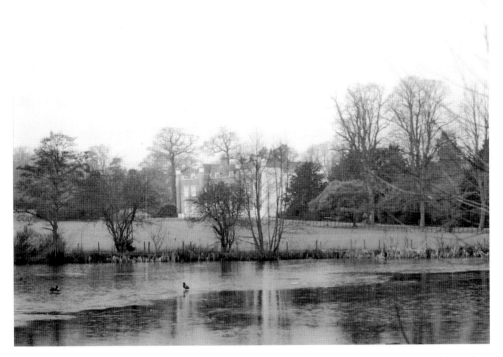

Wistow Hall, November 2006. Compare this photograph with the engraving published in 1821.

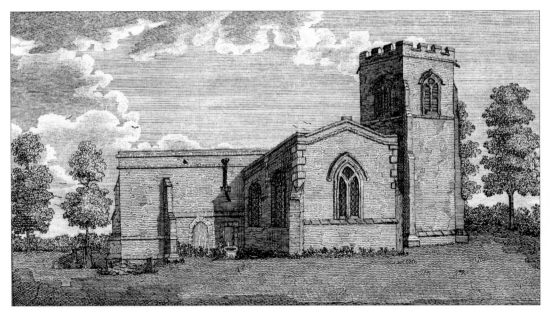

The church of St Wistan, Wistow, north-east view, by Longmate 1791. The vicar in 1798 was Thomas Willows BA.

FIRST CREATION, 1642. SECOND CREATION, 1809.

Mutas inglorius artes.
To exercise, unambitious of glory, the silent arts.

HALFORD, Sir Henry St. John, C.B. Third Baronet of the Second Creation. Born August 9th, 1828; succeeded his father, 1868. Is a Magistrate and Deputy-Lieutenant for Leicestershire and Northamptonshire; was High Sheriff for Leicestershire, 1872; Chairman of Quarter Sessions for Leicestershire; C.B., 1885. Married, 1853, Elizabeth Ursula, daughter of the late W. J. Bagshawe, Esq., of the Oaks, Derbyshire. Patron of Kilby and Wistow, Leicestershire.

HEIR—His brother, Rev. John Frederick Halford, M.A. Born 1830. Married 1856, Ismene, daughter of J. Andrews, Esq.
SEAT—Wistow Hall, Leicestershire. CLUBS—Carlton and Constitutional.

A record of Sir Henry St John Halford, Third Baronet, published by Spencer's Directory in 1896.

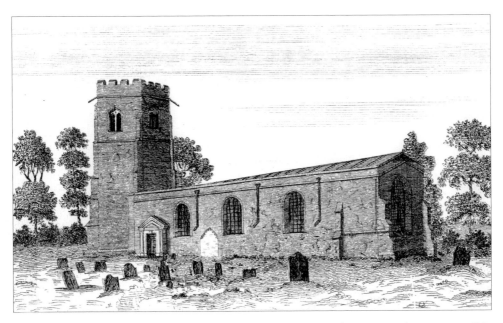

The church of St Wistan is a Norman church with the remains of a Norman doorway, possibly built in the late twelfth century, with considerable extensions made to the building in the late thirteenth century. This is the south-east view. This illustration was drawn and engraved by Prattent in 1792.

The church of St Wistan, November 2006. In parkland near this church are interesting farm marketing interests.

FLECKNEY

Above left: The church of St Nicholas, a south-east view. This illustration was drawn and engraved by Longmate in 1794.

Above right: A silver cup dated 1567 and donated to this church, weighing 5.9 oz. Decorated with fine engraved foliage, the silver paten is also dated 1567, and weighs 2.4 oz.

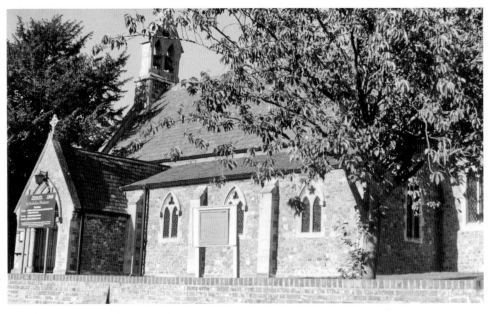

The church of St Nicholas at Fleckney, November 2006. Possibly built in the twelfth century, it was completely rebuilt during the years 1869-70, retaining some of the Norman architecture. Compare this modern photograph with the eighteenth-century engraving printed above.

The harvest festival held in the church of St Nicholas at Fleckney on 3 August 1902.

The vicarage at Fleckney. In 1905 it was the home of Revd Samson Coleman MA, who had resided there from 1885. The vicarage was built in 1860 for Revd Thomas Badcock.

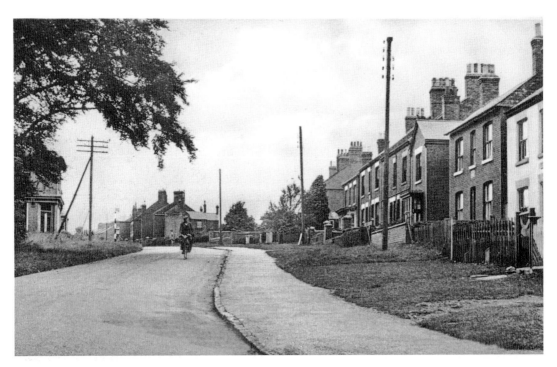

Kilby Road, Fleckney, *c.* 1940.

The 'Old Penthouse' on Mawby's Lane, Fleckney, *c.* 1920.

The junction with the bridge off the High Street, *c.* 1905.

Ernest Price's shop, with Percy Preston's post office opposite, *c.* 1920.

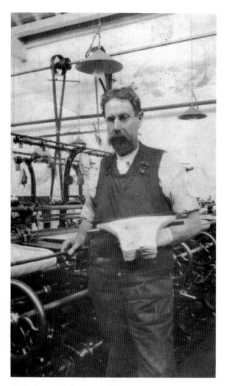

In 1835 Robert Rowley Coy Ltd was involved in building a hosiery factory on Saddington Road. This company moved from Leicester because the factory had been stormed by hand-loom weavers who wrecked the mechanical looms. There were two other hosiery factories in Fleckney, Wolsey Ltd and Wooding & Teasdale. In this photograph William Tebbutt, who lived on Gladstone Street in Fleckney, is producing vests in Robert Rowley's factory in about 1925.

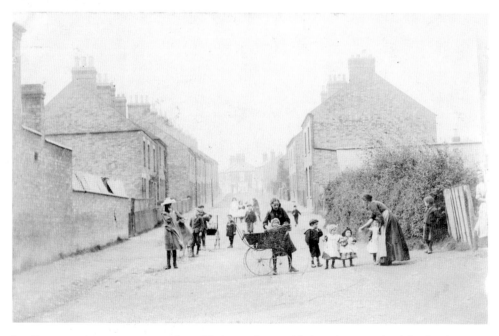

In 1875 an estate was constructed on Gladstone Street; this is a photograph of the development taken *c.* 1905. Public funding was in support of the nearby hosiery factories, the financial group being called 'The New Lands'.

Jack Badcock in 1966. He was born in the village of Fleckney in 1900 and was educated in the local school. On leaving school he worked in the local hosiery industry and in a local shop selling shoes. The *Leicester Mercury* commissioned Jack to write a weekly article on natural history to be illustrated by one of his drawings. He took up the position as author for this paper in 1954 and held this post for over twenty years. He published six books, of which five were published nationally – one, the history of his village, being sold locally. These books deal with the natural history of the stretch of countryside to the north of Market Harborough. The six books are *The Truant, Waybent, A short history of Fleckney, The Four-acre, In the countryside of South Leicestershire, A Countryman's Calendar.*

One of Jack Badcock's drawings of a blackbird in spring at Fleckney, published in 1966.

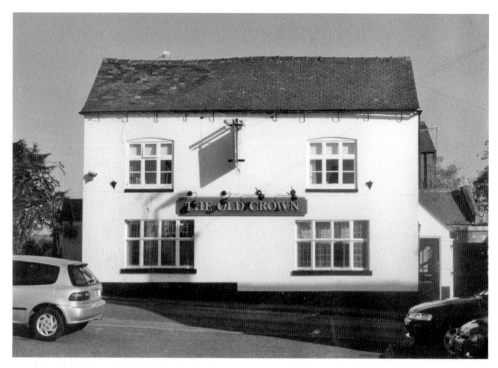

The Old Crown Inn, 7 High Street, Fleckney, October 2006. This public house was built in 1797 by Thomas Decon on the site of a derelict cottage. The landlord brewed his own ale, with the malt produced nearby. Until 1829 it was owned by the Deacon family. It remained in private hands until it was taken over by Everard's Brewery in 1921.

Saddington Tunnel, in 1920, constructed on the Grand Union Canal, which passes between the villages of Fleckney and Saddington.

SADDINGTON

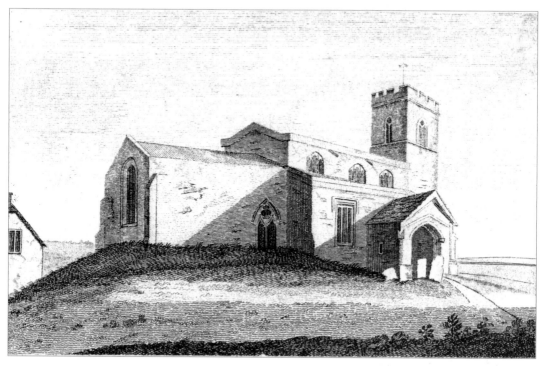

The church of St Helen at Saddington, the north-east view, a drawing produced by Schnebbelie and engraved by Cook, 18 September 1791. In 1797 the vicar was Revd James Hook MA.

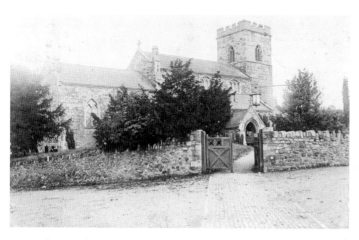

Above left: The church of St Helen at Saddington in 1905. The vicar was the Revd Samuel Wathen Wigg. This church was originally built during the late twelfth century and was virtually rebuilt in 1707 when a spire was removed.

Above right: Revd Samuel Wigg, 1902.

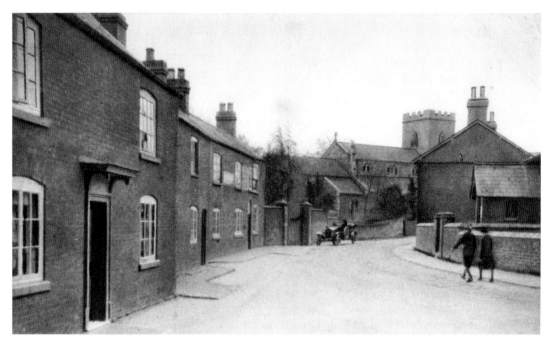

The Main Street, Saddington, with the church of St Helen in the background, *c.* 1920.

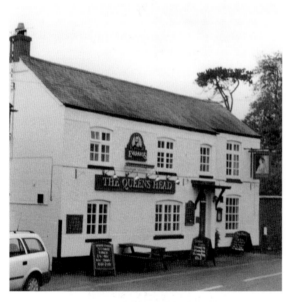

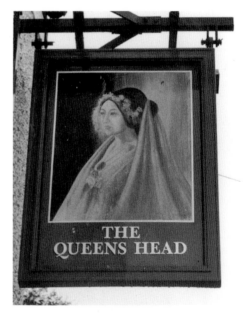

Above left: The Queen's Head public house, Main Street, Saddington, October 2006. In 1905 this inn was run by James Peperby. His brother Walter ran the nearby grocer's shop.

Above right: The Queen's Head hanging at the inn in Saddington. During Queen Victoria's reign one of the consistent landlords was Thomas Dunkley.

SMEETON WESTERBY

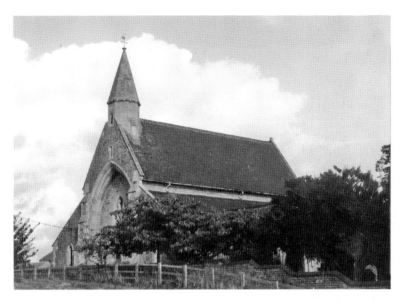

Christ Church, Smeeton Westerby, October 2006. This small church was built during the years 1848-9 to a design by H. Woodyer, under the control of the rector at Kibworth Beauchamp.

The King's Head public house, Smeeton Westerby, October 2006. In 1905 Joseph Grant was the licensee. After the First World War Alexander Askew had taken over this inn.

MOWSLEY

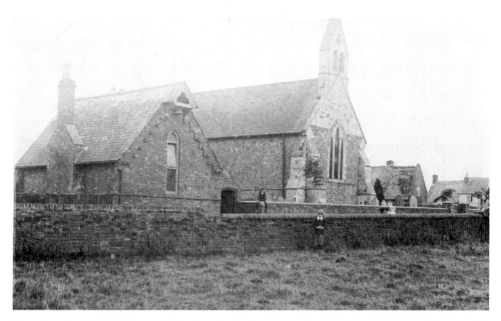

The church of St Nicholas and the local school at Mowsley, 1905. Miss F. M. Adler was the school mistress.

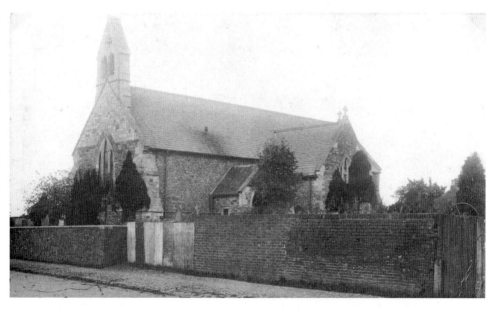

The church of St Nicholas in 1922. The rector was Revd Decimus Albert Gay Taylor. The living was annexed with Shearsby.

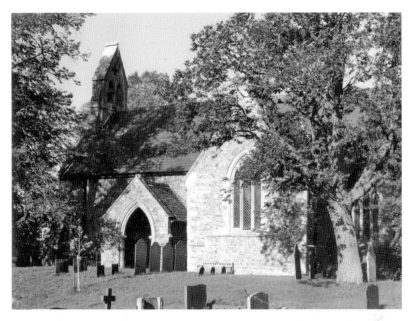

The church of St Nicholas, built during the late thirteenth century. Considerable alterations took place when a major restoration, under the direction of J. L. Pearson, commenced in 1882 and took twenty years to complete.

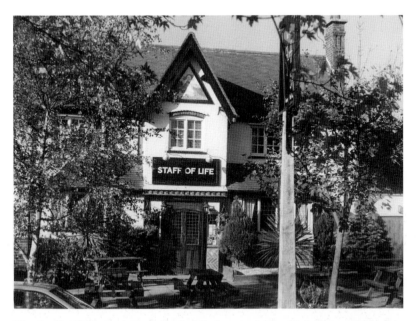

The Staff of Life, an interesting public house on the Main Street, Mowsley. A village court was held involving the surrounding district on a mound in the Mowsley Hills. In 1825, after the local laws had been completed, all the members adjourned to the Staff of Life. The last court was held in 1863. In 1880 John Hart was the licensee.

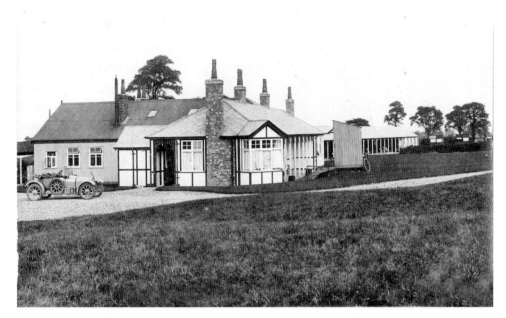

Mowsley Sanatorium. Leicester County Council Sanatorium was built 1914-15 to hold fifty patients. This is a contemporary photograph taken by the photographic dealer Moore of Clarenden Park, Leicester, in 1915. This sanatorium was constructed to hold tuberculosis sufferers.

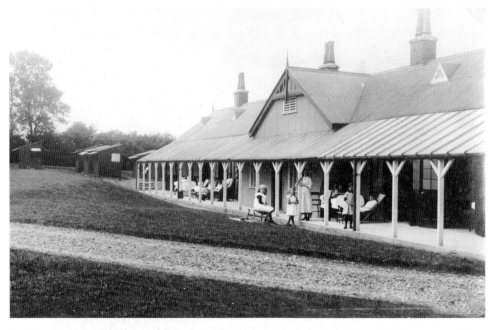

Staff and patients on the veranda at Mowsley Sanatorium in 1915. The administrator was Tom Robinson, and John Tabuteau Crowe was the medical officer. The matron was Miss E. Merson.

LAUGHTON

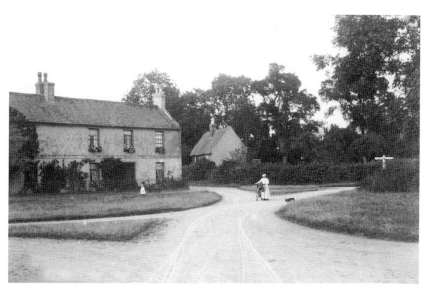

The crossroads at Laughton in 1906.

A fine thatched cottage near the church of St Luke at Laughton, October 2006.

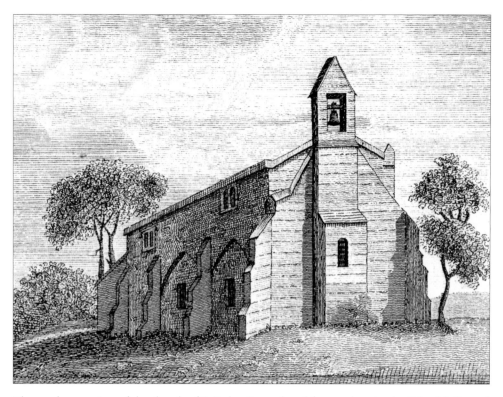

The north-west view of the church of St Luke. Reproduced from a drawing by Schnebbelie and engraved by Swaine, September 1791. It features the alterations that took place in 1784 when most of the thirteenth-century church was pulled down and rebuilt.

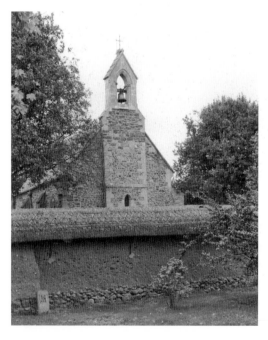

St Luke's church at Laughton in the years 1879-80. Considerable changes to the building were made under the direction of C. Kirk of Sleaford. Compare the photograph of October 2006 with the eighteenth-century engraving. Protecting the church is a mud wall with a thatched cap.

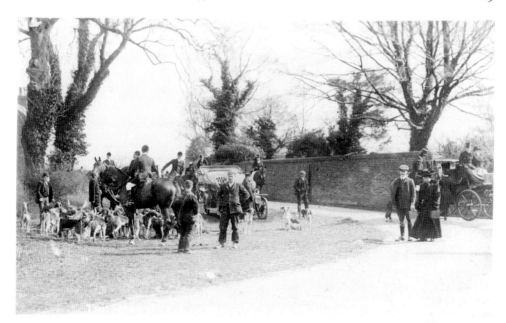

A photograph of the Fernie Hunt (Harborough/Billesdon Hunt) meeting at the crossroads at Laughton in possibly 1908 – C. B. Fernie was the master and Arthur Thatcher was the huntsman. In May 1921 this hunt was called 'Fernie's Hunt' after its famous master, and in the 1930s it became the Fernie Hunt.

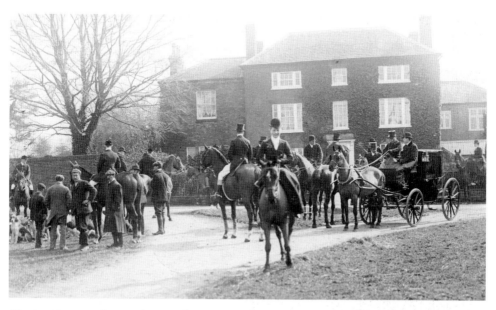

Chasing Foxes in the Laughton Hills was considered to be a most interesting area to hunt. The Fernie Hunt was formed when wealthy landowners quarrelled on where hunts should take place. Part of the Quorn Hunt was separated by Sir Richard Hutton in 1853 to be called the Billesdon Hunt by W. W. Tailby for many seasons. This photograph was taken at the same time as the one printed above it.

GUMLEY

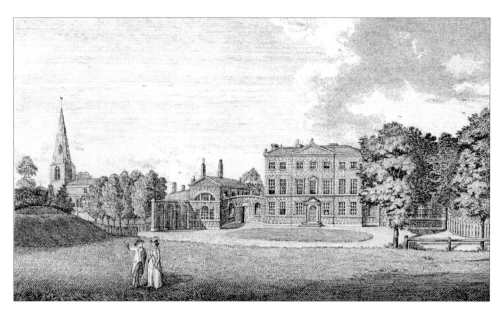

Gumley Hall and the church of St Helen. A drawing produced and engraved by B. Longmate in 1796. The Hall was built by Joseph Cradock in 1764, and the church was constructed in the thirteenth century.

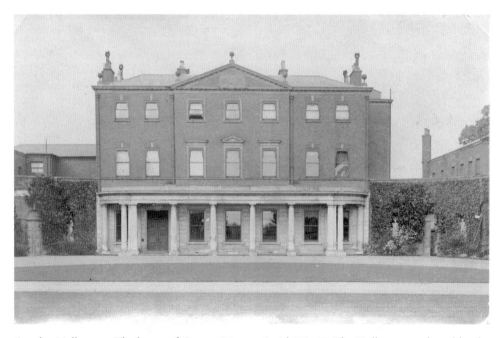

Gumley Hall, 1905. The home of George Murray Smith DL, JP. The Hall was purchased by the Smith family in 1897, and they owned it until 1940.

Gumley Hall in the 1920s. It became vacant in the 1940s. From 1946 to 1948 Group Capt. Leonard Cheshire rented the hall and converted it into flats as an experimental recoupment centre for ex-servicemen and their families. In the 1950s it was let out as flats, and it was demolished in 1964.

Revd John Henry Overton DD, vicar at the church of St Helen at Gumley in 1902.

The church of St Helen at Gumley in 1927, surrounded by trees. The vicar was Revd George William Rudgard Chaplin Kent MA.

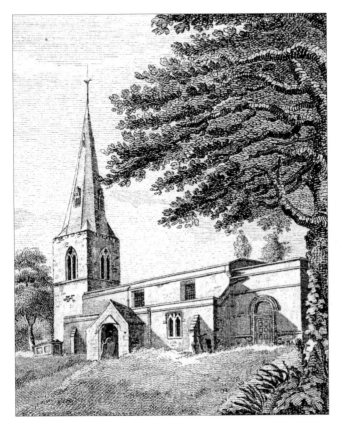

The church of St Helen viewed from the south. A drawing produced and engraved by B. Longmate in 1796. There was possibly a Saxon church standing near the present church, according to the Domesday Book, to be demolished. It would seem the present church was constructed in the fourteenth century.

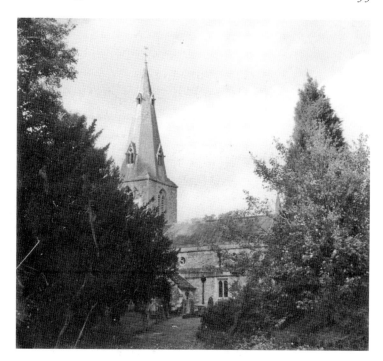

The church of St
Helen at Gumley,
October 2006.
The Hall has gone
and only the stable
block, built in 1869,
remains.

The Bell Inn, Gumley, situated on the Gumley to Foxton road. Providing sustenance to the individuals servicing Foxton Locks. At the height of the trade before the First World War, Alfred Coleman was the licensee. In 1916 William Joseph Richards ran this public house.

FOXTON

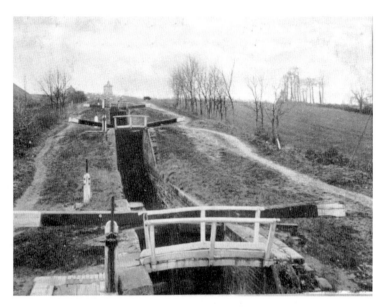

Foxton Locks on the Grand Union Canal. The locks were built between the years 1808 and 1814. Ten locks carry boats up on a 75-foot rise involving a number of water-supplying ponds. The lock-keeper's cottage stands at the top of the hill.

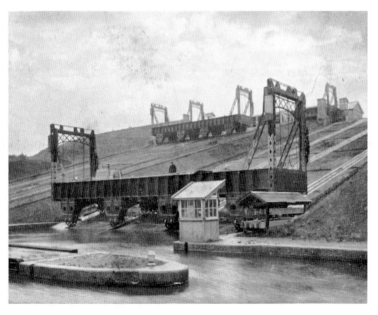

Foxton incline plane was opened in 1900; this photograph was taken in 1907. The lift system took three years to build at a cost of £250,000.

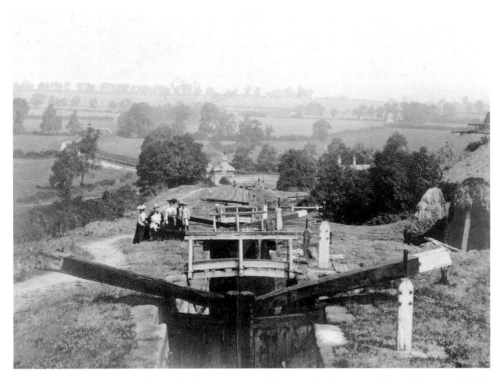

Looking down Foxton Locks, with the company offices at the bottom of the collection of locks in 1900.

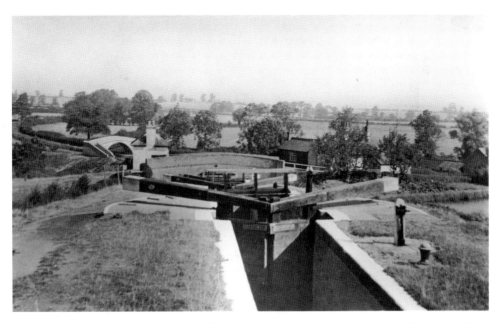

Foxton Locks in 1920, with the canal office and bridge number sixty-one in the background.

The basin at the foot of Foxton Locks, viewed from the canal branch leading to Market Harborough in about 1905. The two counterbalanced water tanks carried a boat to the top or bottom of the lift in eight minutes. A narrowboat takes at least one hour to 'climb' the 'staircase'.

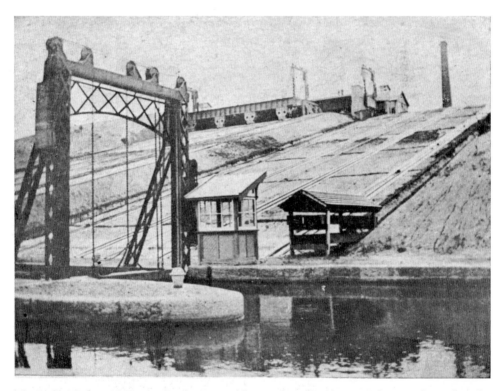

The inclined plane at Foxton Locks. It would seem that this photograph was taken when the steam-powered boat-lift was closed in 1911. Boat users considered it to be too costly to operate and there was insufficient use. Today plans are being considered to rebuild the inclined plane.

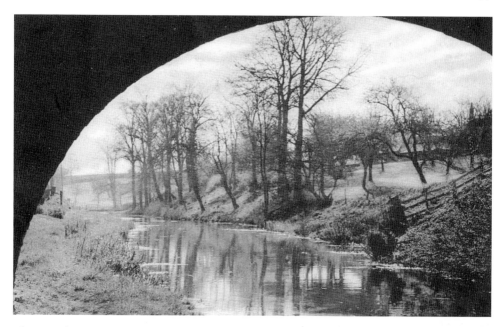

The Grand Union Canal viewed from underneath Swing Bridge, Foxton, in the 1930s.

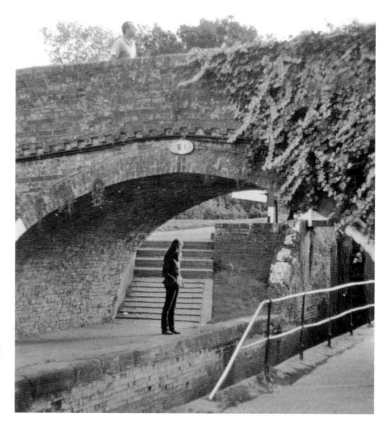

Amy Grech standing under bridge sixty-one at the bottom lock, Foxton, October 2006.

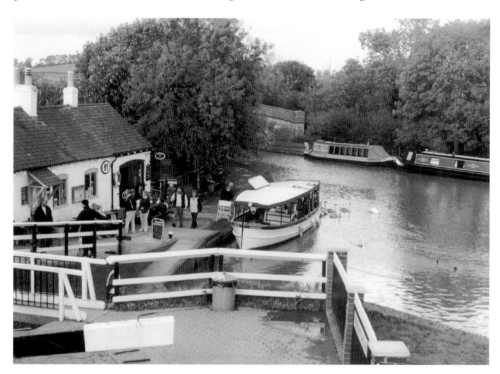

The tourist shop at bridge sixty-one, on the Grand Union Canal, October 2006, with *The Vagabond*, which conducts trips along the canal collecting passengers.

Workshops situated on the junction of the Grand Union Canal that leads to Market Harborough, October 2006.

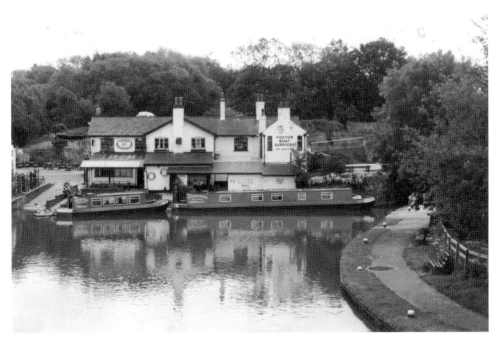

Foxton Boat services the barn at Foxton Locks in October 2002.

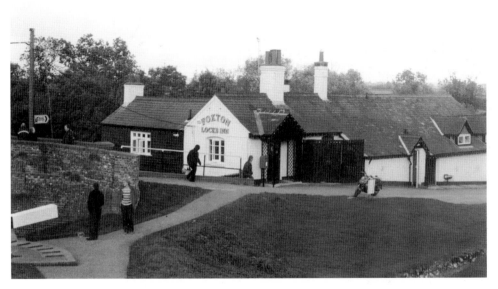

Foxton Locks Inn, Gumley Road, Foxton, October 2006.

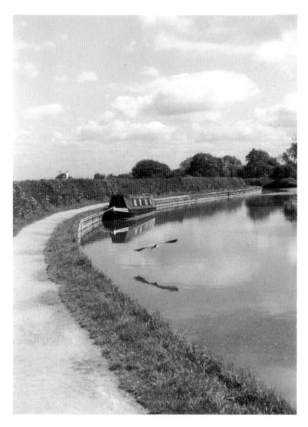

The Grand Union Canal at the top of Foxton Locks, with a heron about to land, August 2002.

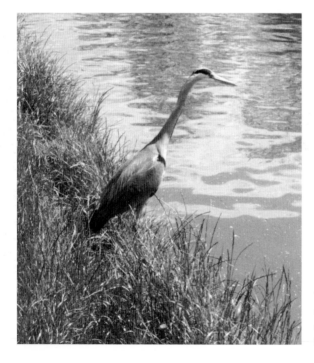

The heron has landed, and is walking along the banks of this canal, considered to be a nature trail, in August 2002.

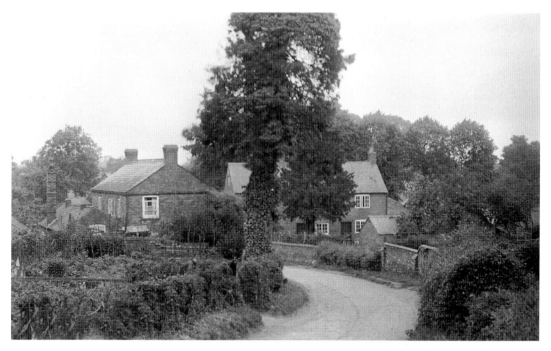

Entering the village of Foxton in the 1940s.

The village of Foxton after the Second World War, with the church of St Andrew in the background.

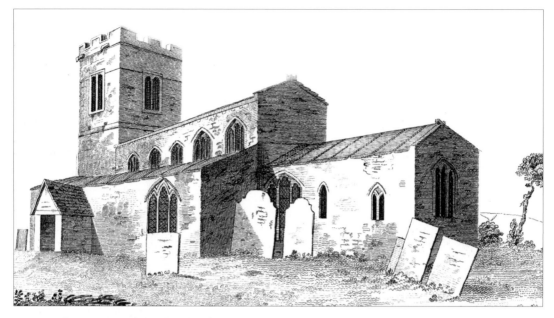

South-east view of the church of St Andrew, a drawing by Schnebbelie, engraved by Cook, 18 September 1791.

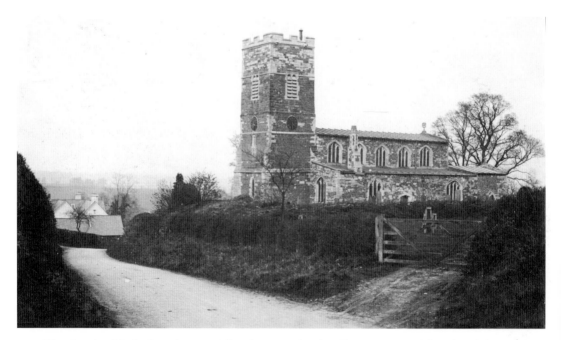

The church of St Andrew in 1904. The vicar was Revd William Scott BA. This church has an interesting history; a Saxon church is recorded to have possibly been built on the present site in 1086. Saxon carvings have been retained in this building. In 1109 it was granted to Daventry Priory; the font is of Norman construction on an octagonal base. Considerable alterations have been made during the thirteenth, fourteenth, sixteenth and the nineteenth centuries.

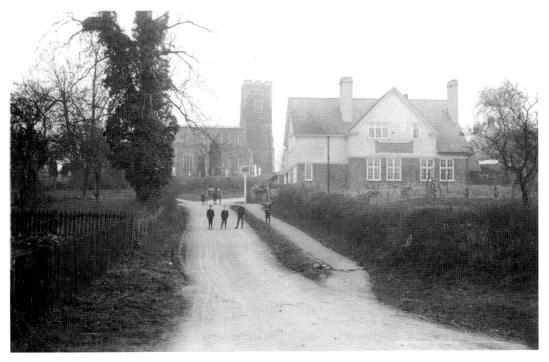

The Black Horse public house in 1914; the landlord was Harry Hemings. In the background stands the church of St Andrew, where the vicar was Revd Francis Samuel Edmonds MA.

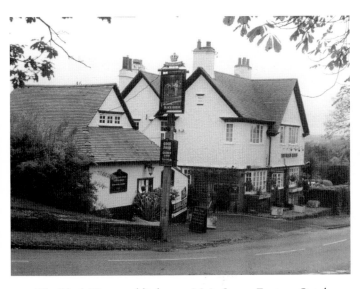
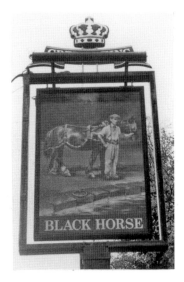

The Black Horse public house, Main Street, Foxton, October 2006.

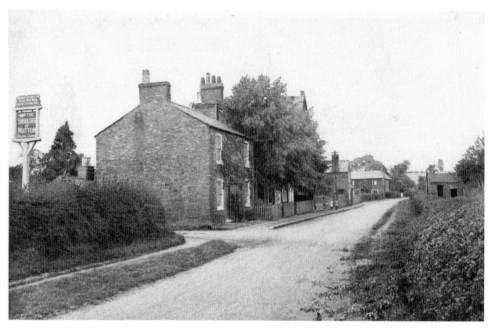

The inn sign indicating the Shoulder of Mutton public house, on the main road through Foxton in 1923. The licensee of this inn was William James Tombs.

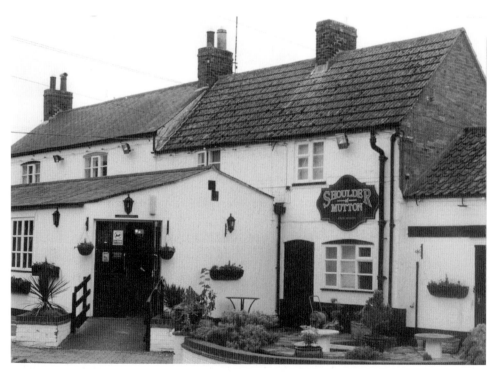

The Shoulder of Mutton public house, 60 Main Street, Foxton, October 2006.

LUBENHAM

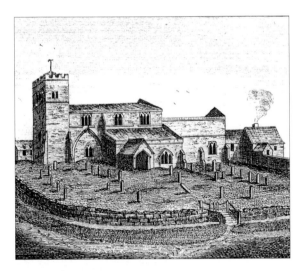 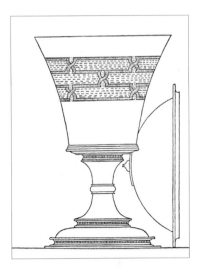

Above left: A south-west view of All Saints' church. A drawing by J. Pridden, engraved by Liparoti, 15 June 1791.

Above right: A silver cup donated to All Saints' and dated 1575, weighing 5.8 oz. The silver paten is of the same date, weighing 2.8 oz.

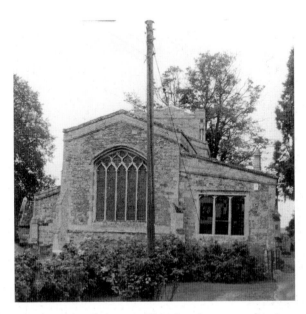

All Saints' church, Lubenham, October 2006. This church was standing in 1109. Possibly a very early Norman church, stone work has survived with carvings that pre-date 1200. In the church there are thirteenth-century alterations, and further changes and restorations were undertaken in the Victorian period.

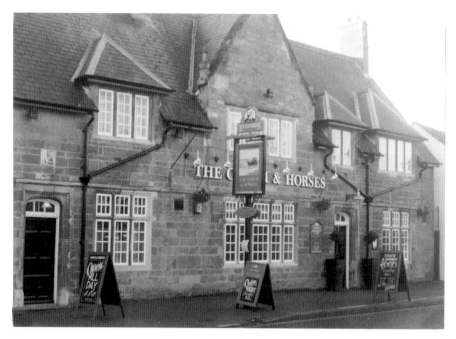

The Coach & Horses public house, Main Street, Lubenham, December 2006. Above the door is a carved inscription: S. J. A. 1700. This hostelry was built from local stone to cater for the coaching trade leading into Market Harborough and beyond. Considerable extensions took place in 1816.

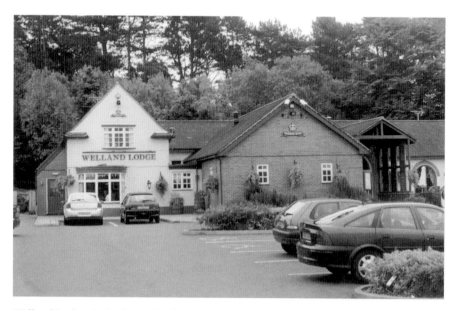

Welland Lodge, Lubenham Heights, Lubenham, October 2006. A modern development under the direction of Greene King stands in an extensive area of land. In February 2010 this licensed premises was taken over by new owners, the building to be put to other uses.

THEDDINGWORTH

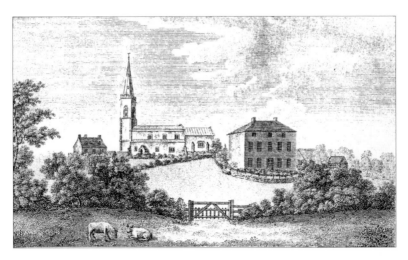

The church of All Saints, Theddingworth, with the vicarage. A drawing by
J. Bidden engraved by John Cary, 8 June 1792.

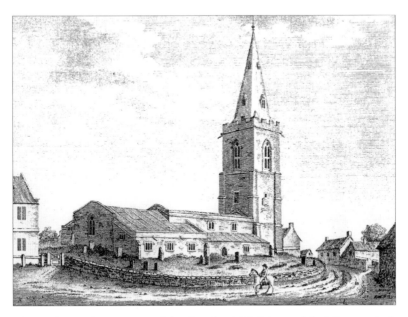

This is the north-east view of the church of All Saints at Theddingworth. A
drawing by J. Pridden, engraved by John Cary, 13 June 1791 – interestingly,
one year earlier than the engraving printed above. This is possibly a very
early Norman church. It is on record that it was granted to Alcester Abbey
in 1150. There is evidence of a number of improvements and alterations
conducted in the thirteenth century. In 1858 G. G. Scott undertook a major
restoration – typical Victorian improvement!

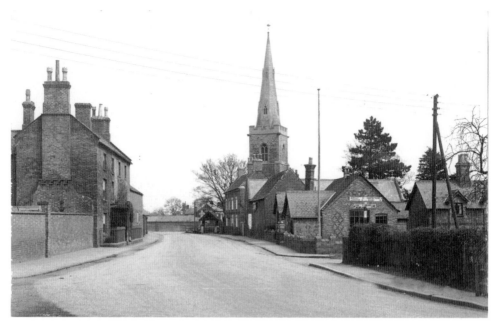

The vicarage featured in the engraving printed on the top of page 47 with the eight windows stands in front of All Saints' church at Theddingworth. This photograph was possibly printed when the vicar was Revd John Townsend Goodchild MA in 1932.

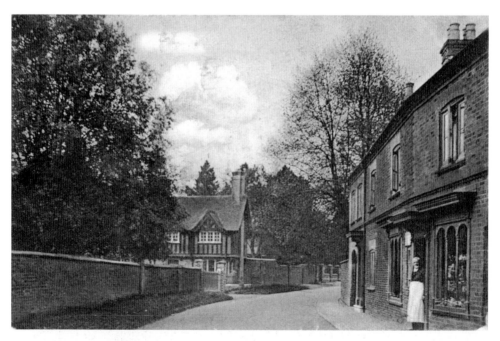

The High Street, Theddingworth, in 1905. In this photograph, possibly Matthew Rodwell is standing in front of his shop. The Rodwell family were involved in many businesses in this village.

HUSBANDS BOSWORTH

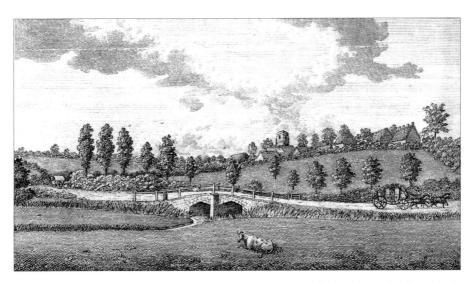

An interesting engraving, published in 1796 by Longmate, of the bridge south of Husbands Bosworth (on the Leicestershire/Northamptonshire border), featuring a carrier's cart and a four-horse carriage. Across this road bridge, leading to Market Harborough, the defeated army fled north after the Battle of Naseby, with Charles I leading the retreat in 1645.

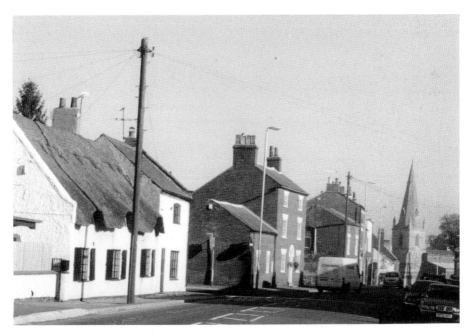

The main street, Husbands Bosworth, with an interesting thatched cottage and the church of All Saints in the background, October 2006.

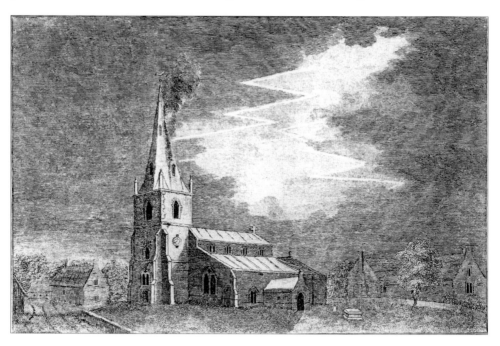

An engraving of the church of All Saints, Husbands Bosworth, published by Basire in 1789, recording the storm that damaged the spire and the church in 1755. The church was constructed in the twelfth century and endowed to Leicester Abbey. The majority of the church was constructed in the fourteenth century. Most of the existing building is High Victorian, restoration taking place during the years 1861-67.

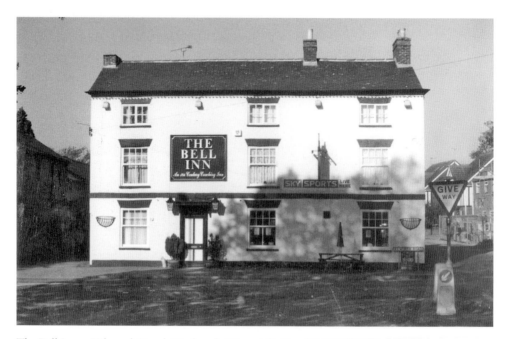

The Bell Inn, 2 Kilworth Road, Husbands Bosworth, October 2006.

Above left: The church of All Saints at Husbands Bosworth, October 2006.

Above right: Revd Maurice Lamb MA, vicar of the church of All Saints, Husbands Bosworth, 1902.

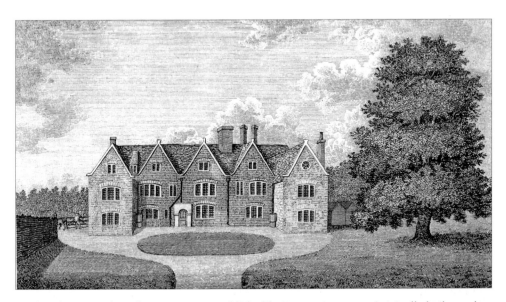

Husbands Bosworth Hall, an engraving published by Longmate, 1784. Originally built as a late fifteenth-century great hall, it is a complex building with many extensions having been made, mainly throughout the sixteenth century. This hall became a centre for Catholicism from 1630. In a major rebuilding programme a priest's hole was constructed next to the north chimney stack.

MARKET HARBOROUGH
& DISTRICT

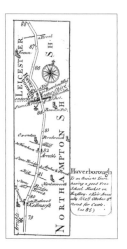

Above left: The London to Leicester road passing through Market Harborough. Part of a strip map from *Britannia Depicta* engraved by Emanuel Bowen in 1720, taken from Ogilby's maps of 1675. Bowen's maps were reproduced in the first pocket-size road atlas ever published, to be carried in large pockets by post boys who travelled the highways of England delivering mail.

Above right: A map published in the 1920s indicating the Market Harborough area.

Market Harborough is made up of three districts; the town, Little Bowden and Great Bowden. Harborough was first mentioned in 1176 as a new road crossing of the River Welland, part of Great Bowden parish and granted a market in 1202. A few houses were constructed and the main market was held in the fields of Great Bowden. This expanded into Harborough. Little Bowden (Bowden Parva) was expanding south of the river, in Northamptonshire. The town of Market Harborough grew, expanding into the two villages and over into Northamptonshire. In 1888 moves were made to include Little Bowden in Leicestershire. In 1894 the Local Government Act made this legal. Today the urban area south of the River Welland is the district of Little Bowden. To many locals who do not study history, this is very misleading.

MARKET HARBOROUGH

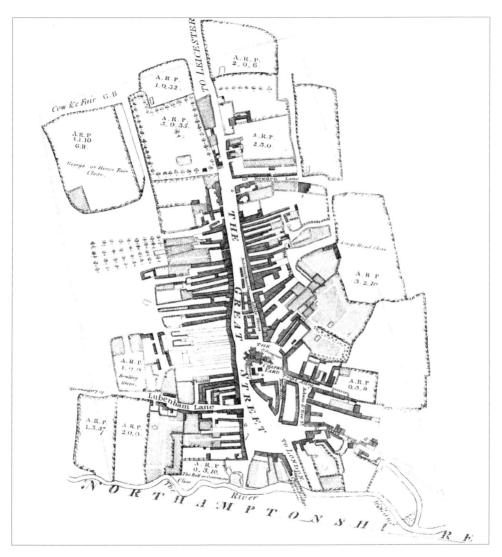

This is a town map of Market Harborough published in 1776, drawn and compiled by Samuel Turner and Rowland Rouse. Below is a list of some of the features published on this map.

1. Protestant Dissenters' Meeting House and Burial Ground.
2. House purchased for the Minister.
3. Free School founded by Robert Smyth.
4. Guard House.
5. Quakers' Meeting House and Burial Ground.
6. House belonging to the Master of the Free School.
7. Parsonage House.
8. Antinomian Meeting House.
9. Lady Well dedicated to the Virgin Mary.

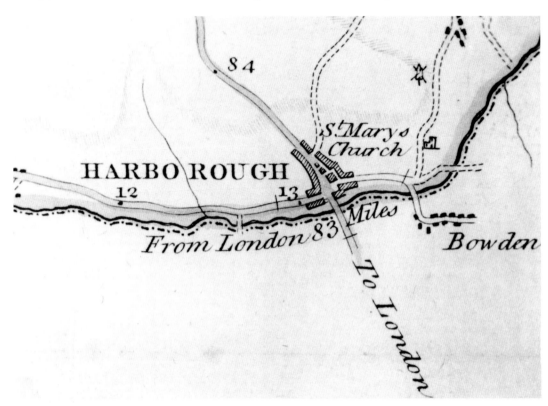

The map of Harborough in 1777 was produced by John Prior from Ashby-de-la-Zouch, who did not consider it a market town, but rather just a collection of houses at a road junction near a river crossing.

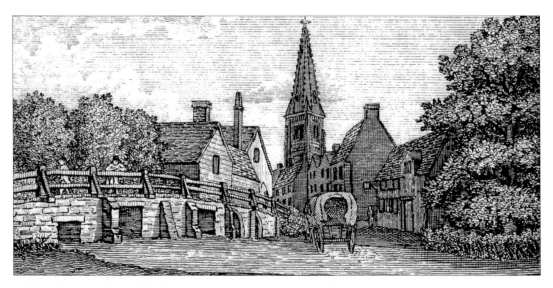

Market Harborough, viewed from across the River Welland, featuring a packhorse bridge with a ford, and a carrier's cart travelling into the town, from an engraving published in 1792.

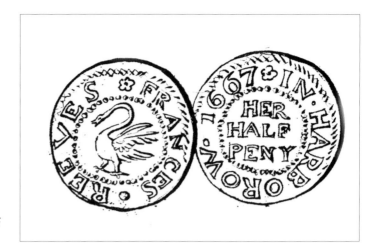

Frances Reeves, halfpenny of
1667.

Thomas Heyricke, halfpenny
of 1668. These two coins were
produced locally. After the
Civil War, coinage became
difficult to obtain. The
government turned a 'blind
eye' on coins being produced
in market towns. Normally
these coins could only be used
to purchase produce marketed
by the individuals listed on
the coins. It is interesting to
note a swan is incorporated
on Reeves' coin. Was this used
at the hostelry that eventually
became The Three Swans
Hotel. Did three coins pay for
a night's lodging?

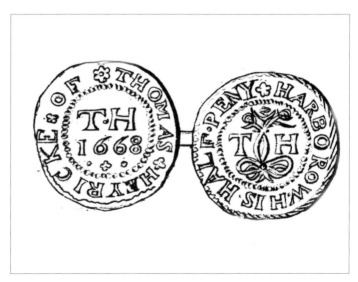

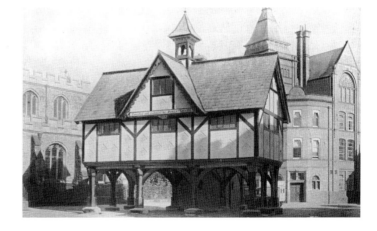

Smyth's Grammar School
founded in 1607, built in
1614. Standing in Church
Square, *c.* 1920.

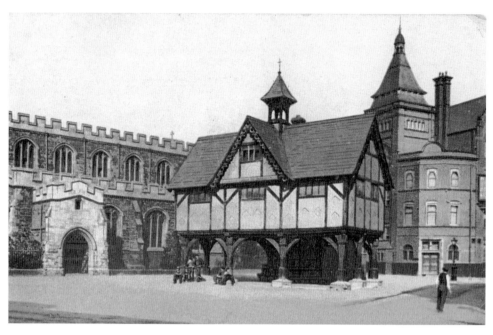

Robert Smyth's Grammar School, *c.* 1920. Built in 1614 at the edge of the market square, it was constructed on posts with an open ground-floor area where markets could be held.

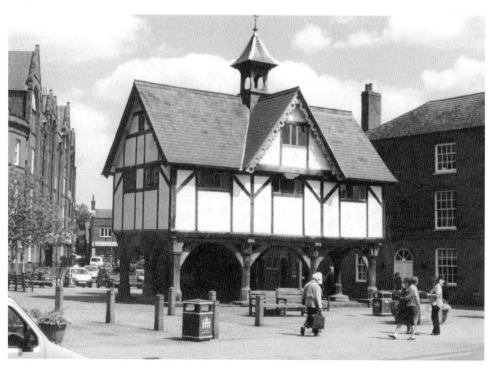

The seventeenth-century grammar school has taken its place in history, standing magnificently in the centre of Market Harborough, July 2002.

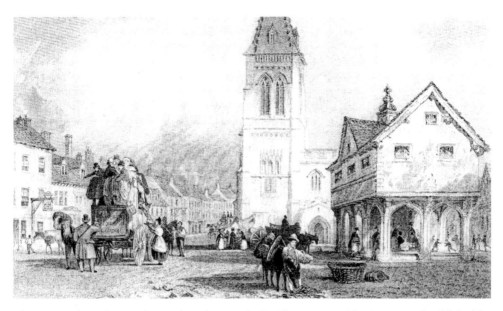

The centre of Market Harborough. A drawing by T. Allan engraved by S. Lacy and published by Fisher & Sons, London, 1837. The Manchester to London stagecoach is being loaded. A loaded packhorse is being fed hay in the centre of the engraving, with the Grammar School on the right and the church of St Dionysius standing high in the background.

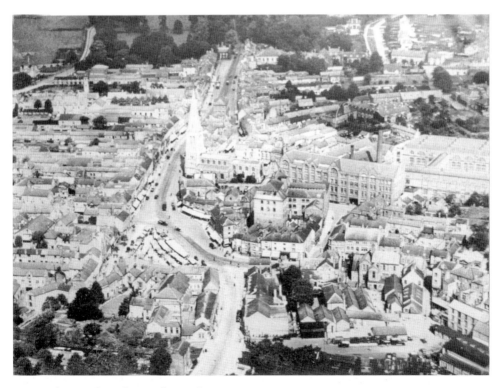

An aerial view of Market Harborough, *c.* 1930.

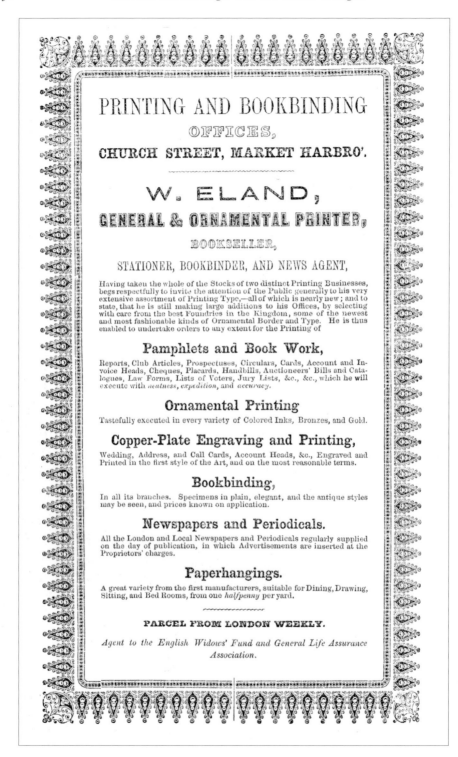

An advertisement published in 1849 by W. Eland for his business on Church Street, involved in printing, engraving and bookbinding.

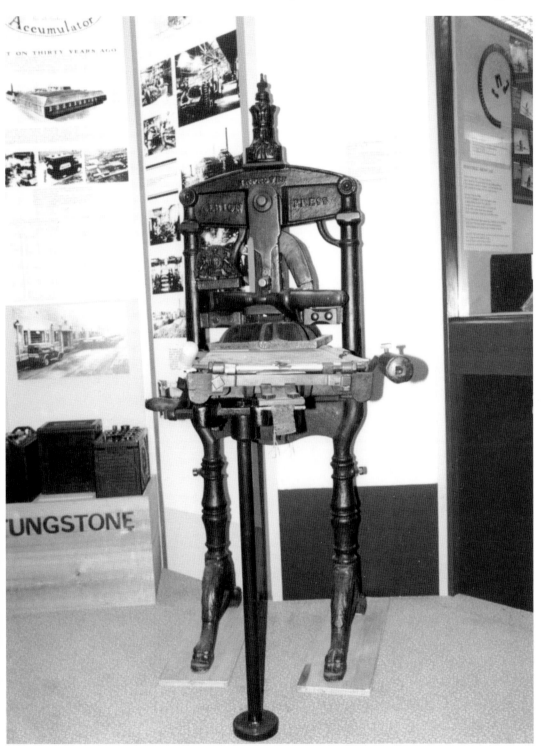

An Albion printing press, a type that was used by W. Eland. On display in Market Harborough museum, July 2002.

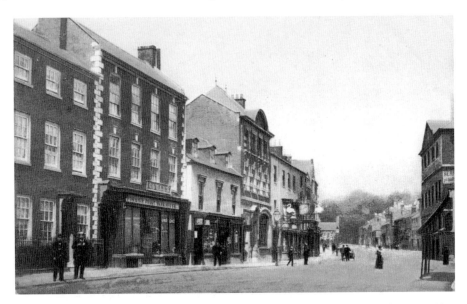

High Street, Market Harborough, with Goward & Sons grocers at 18 High Street. Also featured is The Three Swans Hotel, when R. Marriot was licensee.

FASHION'S FAVOURITE;
OR, THE MART OF THE MANY!

S. S. FLAVELL,
TAILOR AND WOOLLEN DRAPER,
CLOTHING, HAT, CAP,

AND

GENERAL OUTFITTING ESTABLISHMENT,

AND AGENT FOR

MOORE'S Celebrated French & English STAYS & CORSETS,

CHEAPSIDE,

(Opposite the Town Hall,)

MARKET HARBOROUGH,

An advertisement published in 1849 for S. S. Flavell, a Woollen Draper dealing in fashions of the day, situated on Cheapside, off High Street, near the Town Hall.

THE MIRROR OF FASHION,

OR

MART OF THE MANY!

S. S. FLAVELL,

FASHIONABLE AND PRACTICAL

TAILOR,

CHEAPSIDE, MARKET HARBOROUGH.

Gentlemen's Yearly Contracts

MOURNING EXECUTED ON THE SHORTEST NOTICE.

Liveries, Children's Dresses, &c.

Sole Agent for Nicolls, Tailors,

Nos. 114, 116, 118, 120, REGENT STREET, LONDON,

REGISTERED PALETOTS AND TOGAS,

AND GENERAL

OUTFITTING ESTABLISHMENT

HATS & CAPS

OF

THE NEWEST FASHIONS, AT UNPRECEDENTED LOW PRICES.

BURKE'S BLACK & DRAB WATER REPELLANTS,

Suitable for all Climates.

COTTON AND MERINO DRAWERS, SHIRTS, NECK TIES, COLLARS, &c., IN GREAT VARIETY.

AGENT TO THE ALBION LIFE INSURANCE COMPANY.

Observe the Address! **S. S. FLAVEL, CHEAPSIDE, MARKET HARBOROUGH.**

S. S. Flavell's advertisement of 1854.

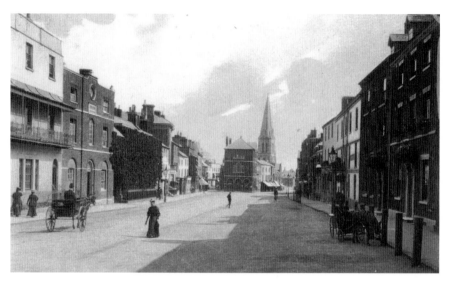

High Street, Market Harborough, viewed from the road to Leicester before the First World War.

WILLIAM STANYON,

WHOLESALE AND RETAIL DEALER IN

London, Birmingham & Sheffield Goods,

SMALLWARES, &c.,

Church St., Market Harborough.

Table Knives, with all description of Cutlery, Fenders, Fire Irons, Tea and Coffee Pots, Spoons, Tea Trays, waiters, with Brushes, Combs, &c., &c., always on hand.

N.B. TRAVELLERS SUPPLIED.

This is an interesting advertisement published in 1854. William Stanton is on Church Street, Market Harborough, dealing in small household goods, with the notice that travellers are supplied, fairly certain to be the packhorse trade.

JAMES AND EDWARD FLINT,

IMPORTERS OF

WINES AND SPIRITS,

MALTSTERS,

AND

HOP MERCHANTS,

DEALERS IN

PALE ALE,

LONDON AND COUNTRY PORTER,

HIGH STREET,

MARKET HARBOROUGH.

James and Edward Flint's advertisement of 1854. They were situated on High Street, Market Harborough. As they were maltsters, they must have been producing a local strong beer.

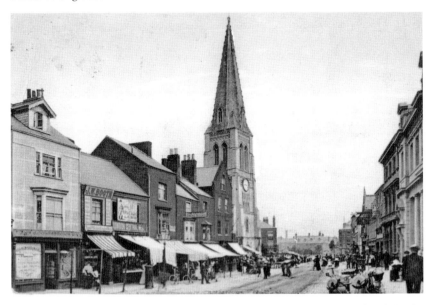

This is a very interesting photograph produced in 1905, depicting market day. The photographer stood in High Street, leading into the market square. On the left, clearly indicated, stands James William Booth, a confectioner at 65A High Street with a café at 68 High Street.

WILLIAM BUSWELL,
COOPER AND TIMBER MERCHANT,
HIGH STREET,
MARKET HARBOROUGH,

Begs respectfully to inform the Nobility, Clergy, Gentry, and Inhabitants generally of the Town and Neighbourhood of Market Harborough, that he has taken the extensive premises lately occupied by Mr. H. FOSTER, Auctioneer, and has added to his former business that of an

Upholsterer, Cabinet Maker,
AND
GENERAL FURNISHING AGENT,

And has always on hand a large and well-selected STOCK of

NEW AND SECOND-HAND MODERN

DINING, DRAWING, BEDROOM, AND OTHER FURNITURE,

IN ROSEWOOD, MAHOGANY, OAK, &c.,

To which he has much pleasure in inviting their attention; sincerely thanking those who have hitherto so kindly and liberally extended their patronage to him, and begs to assure them that every exertion will be made to merit a continuance of their support

Extensive Show Rooms for Gilt Pier, Chimney, Dressing, and other Glasses of all descriptions.

FEATHER & FLOCK BEDS, MATTRESSES, &C.

GOODS MADE TO ORDER.

Brussels and Kidderminster Floor and Stair Carpets, Hearth Rugs, Floor Cloths, etc.

William Buswell, cabinet maker, High Street, Market Harborough, in 1854. A very interesting advertisement, and one wonders if he named his furniture and what would it make at an antique fair today?

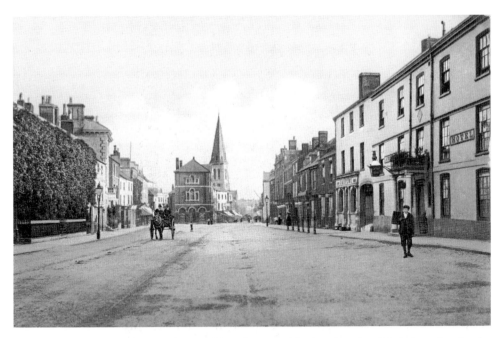

The High Street, Market Harborough, in 1905, with the church of St Dionysius in the background. On the left is J. & E. Flint, wine, spirit and ale merchants, 36 High Street (see the advertisement printed on the top of page 63). A young man stands in front of the Angel Hotel where Mrs Mary Wooton was the manageress.

JOSEPH BARBER,

GLASS, CHINA,

AND

STAFFORDSHIRE WAREHOUSE,

CHURCH SQUARE,

MARKET HARBOROUGH.

Joseph Barber's advertisement for glass and china in his shop at Church Square, Market Harborough, 1854.

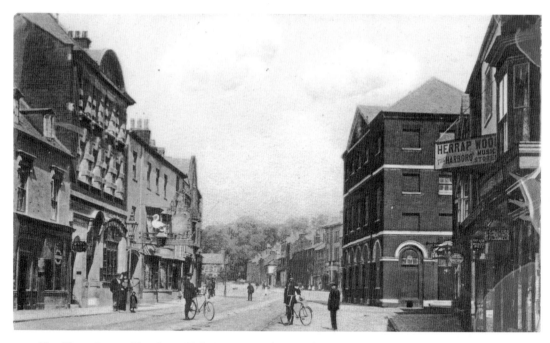

The Three Swans Hotel on High Street, Market Harborough, in 1905, R. Marriot licensee. On the right is the music shop of Herrap Wood, 62 High Street, organist to the church of St Dionysius, professor of music.

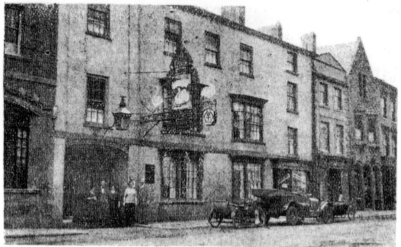

THE THREE SWANS HOTEL, Market Harborough.

FAMILY AND COMMERCIAL.

First class . . accommodation.

Bus meets Trains.

Centrally situated in the High Street.

:: Address all :: communications :

GEORGE CHARLES CRIBBEN,

Proprietor.

An advertisement for The Three Swans Hotel, High Street, Market Harborough, 1922, when George Charles Cribbon was the owner. This is a famous hostelry, first mentioned in 1517. Then named The Swan, from 'one' it eventually became 'three'! Some of the interior panelling and the timber framing are considered to have been incorporated into the structure in 1700.

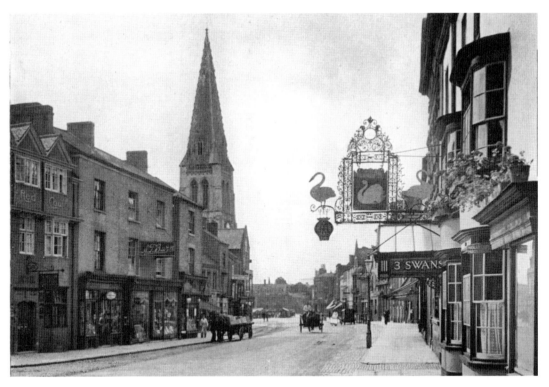

The Three Swans Hotel, 21 High Street, Market Harborough, displaying a superb ironwork sign in 1933. George C. Booth was the licensee.

CHARLES BETTS,

(From Northampton),

LADIES' & GENTLEMENS' FASHIONABLE,

BOOT AND SHOE MAKER,

HIGH STREET,

MARKET HARBOROUGH.

An advertisement for a boot and shoe maker, Charles Betts on High Street, Market Harborough, 1854.

MARKET HARBOROUGH.

FREESTONE & SON,

Curriers, Levant Dressers,

WHOLESALE & RETAIL LEATHER SELLERS.

MANUFACTURERS OF BOOT & SHOE UPPERS.

Freestone & Son leather tanners at Market Harborough in 1880. Levant is a fine leather produced from goat skin that was obtained in Turkey. It has a very prominent natural grain, used in the production of fine shoes and for covering large family Bibles.

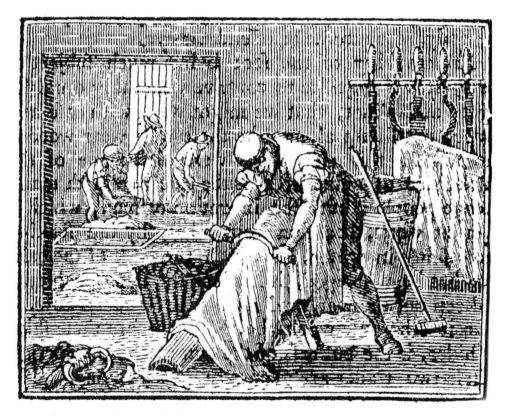

A wood engraving showing a leather tanner at work, dressing a skin.

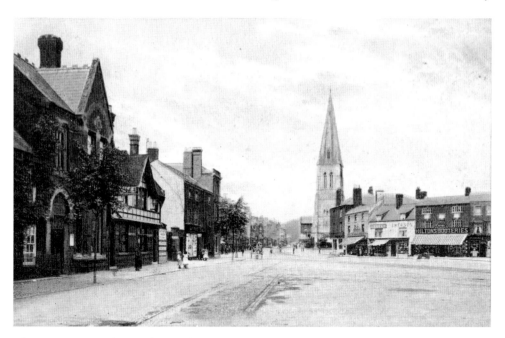

The Square at Market Harborough in 1905. On the right-hand side of the square is Hilton's Booteries, boot and shoe manufacturer, 10 The Square. At number 11 is Joseph Arthur Emerson's bakehouse and café.

JAS. FAIRTHORNE,

CHURCH SQUARE,

MARKET HARBOROUGH,

WHOLESALE & RETAIL

GROCER & TEA DEALER,

HOP AND CHEESE FACTOR.

BRITISH WINE, BISCUIT, & ITALIAN WAREHOUSE.

Jas. Fairthorne's advertisement published in 1854; he was a grocer and general dealer, and factored cheese. Fairly certain to have been Leicester cheese, it could also have been stilton cheese.

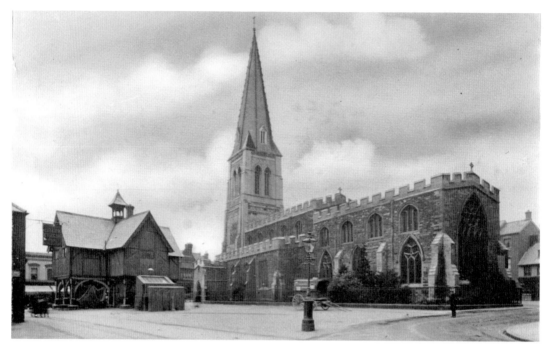

This is an interesting photograph published before the First World War. The church of St Dionysius dominated the area. A carrier's cart is parked in the square. The supporting pillars are clearly indicating part of the rear view of the Old Grammar School. A small building with a sloping roof and a separate protecting wall has been constructed behind the school. This is an outside latrine for the use of male traders operating out of the market. There was much opposition to this facility, resulting in it being demolished.

B. J. Binley, a building contractor on Coventry Road, Market Harborough, in 1925.

TELEPHONE 6 (Haulage Dept.)

TILLEY, NOBLE & JACKSON

Motor Haulage Contractors

37 COVENTRY ROAD, MARKET HARBOROUGH

Motor haulage contractors, Tilley, Noble & Jackson, 37 Coventry Road, Market Harborough, 1922.

Coventry Road, Market Harborough, in the 1920s, when the two contractors featured in the two advertisements, indicated on these pages, operated on this road.

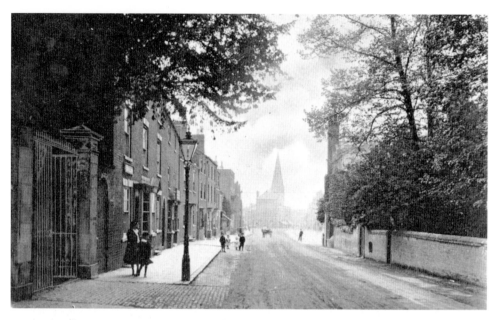

Leicester Road, 1905, leading into High Street, Market Harborough. The Elms is situated on the left; in the distance is the Town Hall and the church of St Dionysius.

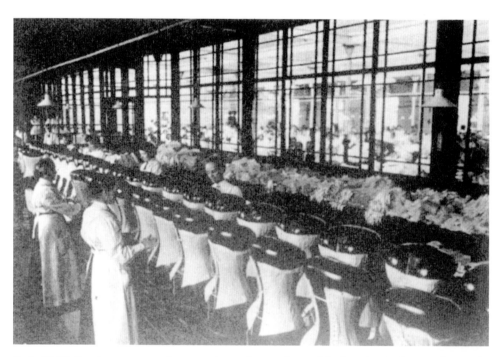

R. & W. H. Symington corset factory, situated near the parish church, Market Harborough, 1908. Hosiery workers are starching and completing corsets.

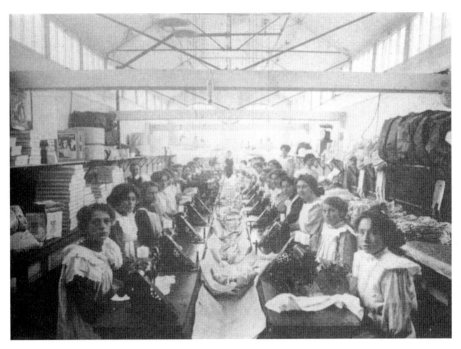

The sewing room in Symington's corset factory, off Adam and Eve Street, Market Harborough, 1908.

WILLIAM MAWSON & Co.,
(LIMITED)
MANUFACTURERS OF HIGH-CLASS
Mineral ∴ and ∴ Aerated ∴ Waters,
(SILVER MEDAL FOR EXCELLENCE)
CHURCH STREET, LUTTERWORTH;
HIGH STREET, MARKET HARBOROUGH.

TRADE MARK.

REGISTERED.

Soda Water. Seltzer Water. Potash Water.
Lithia Water. Lithia with Potash. Magnesia Water.
Quinine Champagne. Lemonade. Gingerade.
Gingerale. Sparkling Table Water.

Analyses, Prices, and Medical Testimonials by post.

TELEGRAMS: "MAWSON, LUTTERWORTH."

William Mawson & Company, manufacturers of mineral water on High Street, Market Harborough, 1896. In 1905 the works was situated at 22 Market Square, within very easy reach of the thirsty workers from the nearby corset factory.

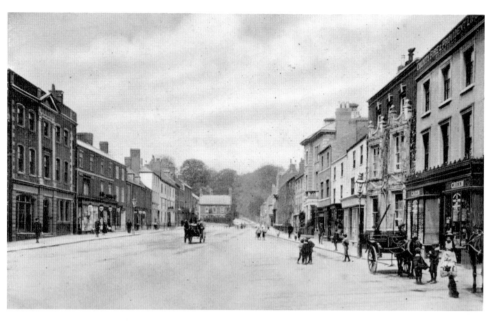

The High Street, leading into Leicester Road, Market Harborough, 1904. On the right is George Green's shop, bookseller, printer, stationer and newsagent. Also, he was an agent for the Country Fire & Provident Life Insurance.

Hopton & Sons timber merchants, situated on Leicester Road, Market Harborough, 1904. In this advertisement the promotion of timber used in the production of carriages, carts, wagons and motor vehicles was a speciality.

ST. MARY'S MOTOR Co.

ST. MARY'S RD., MARKET HARBOROUGH.

Agents for

HUMBER, PAIGE & FORD CARS
HUMBER & SCOTT MOTOR CYCLES
and NER-A-CARS.

Overhauls and Repainting a Speciality. CARS FOR HIRE.

An interesting advertisement published in 1922. St Mary's Motor Co., St Mary's Road, Market Harborough. All vehicles listed would be collectors' items today.

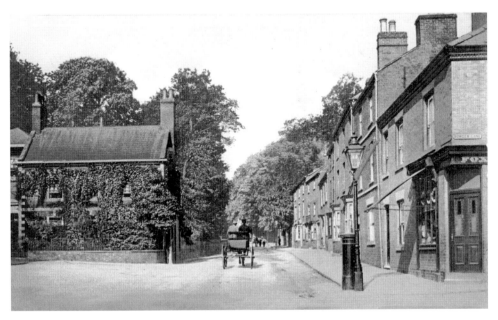

This is a splendid view of the commencement of Leicester Road as it leaves High Street, Market Harborough, in 1904. On the right, leading into Bowden Lane, is Miss Elizabeth Fox's general shop at No. 1 Leicester Road.

Holloway, Price & Co., auctioneers at Market Harborough in 1922. William Green, FAI, sold cattle in the local market specialising in the weekly sheep auctions.

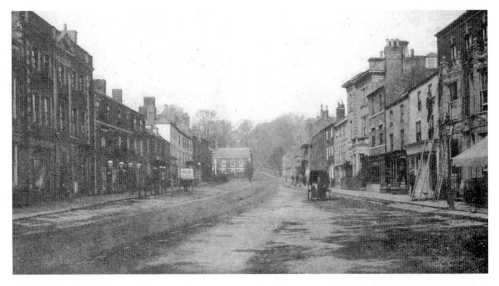

A wet day, possibly during the winter of 1906. There are a number of questions to be asked about this photograph. Why take it? Was it a record of work on the Victorian house to the right. Or did someone wish to have a photograph of the handcart conveying goods to the weekly market at the end of High Street?

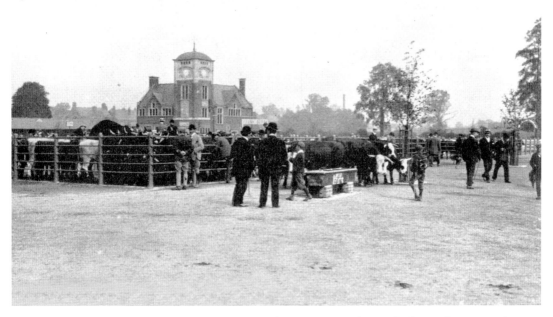

The sale of steers and bullocks at the cattle market, Market Harborough, during the 1920s. The person wearing the straw hat is possibly William Green.

BENJAMIN SHAW,

LADIES' & GENTLEMEN'S

FASHIONABLE BOOT & SHOE

MAKER,

SHEEP MARKET,

MARKET HARBOROUGH.

This advertisement was published in 1854. Benjamin Shaw's shop is in the Sheep Market, an ideal place to sell boots and shoes to the farmers visiting the weekly market.

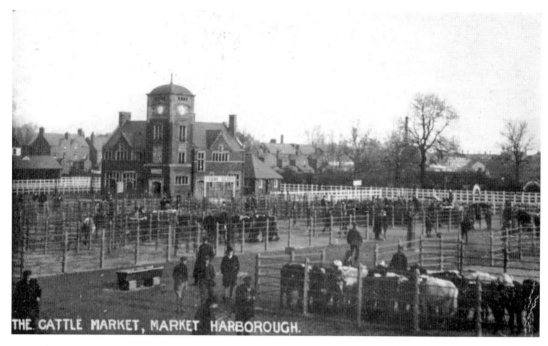

The Cattle Market at Market Harborough in 1906, with a very small attendance. Possibly it was a cold winter's day. On display is an advertisement for Frank Berry (who auctioned sheep and cattle). His offices were situated at 22 Adam and Eve Street.

Telegrams: " Toller Eady, Market Harborough." Telephone No. 129 (Office)

J. TOLLER EADY, F.A.I.

(Partners : J. TOLLER EADY, F.A.I. and W. S. BURMAN),

Auctioner, Valuer, Surveyor, House & Estate Agent,

MARKET HARBOROUGH.

FAT AND STORE STOCK SALES CONDUCTED IN MARKET HARBOROUGH MARKET EVERY TUESDAY.

An advertisement for auctioneers J. Toller Eady and W. S. Burman in 1922. They sold cattle and sheep at the Tuesday market in Market Harborough.

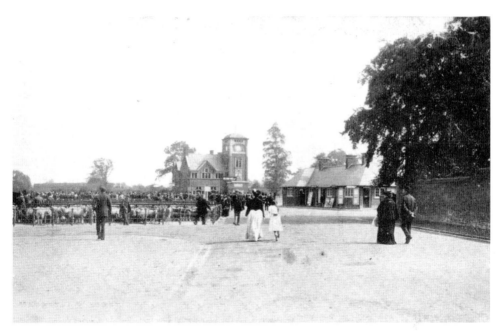

Sheep being sold at auction at the Sheep Market, Market Harborough, *c.* 1905.

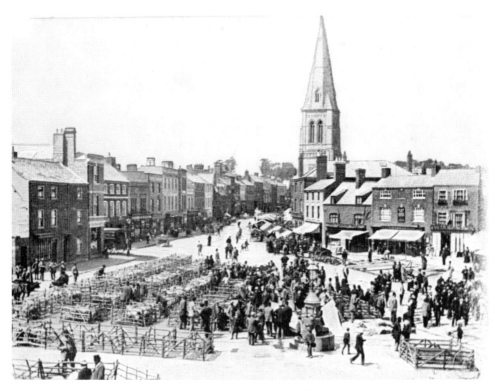

The 'Old Sheep Market' in the Market Square, Market Harborough, *c.* 1900.

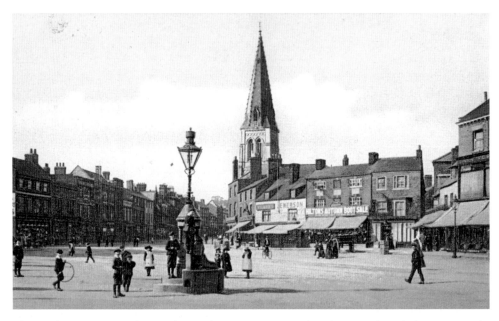

The Market Square, Market Harborough, 1904. Compare this photograph with the image at the foot of page 79 where the sheep market is in full progress. The church of St Dionysius stands in the background with Joseph Arthur Emerson's café; he also baked fresh pies and bread at 11 The Square. At number 10 here is Hilton & Sons, boot and shoe makers, who are having a sale.

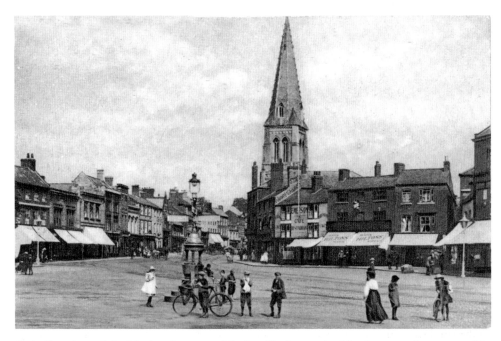

A similar view of the Market Square at Market Harborough, this photograph was possibly taken in 1910. Emerson's is obviously enjoying excellent trade. They have extended the height of the building and it is now classed as a restaurant. Hilton's are still in the boot and shoe trade.

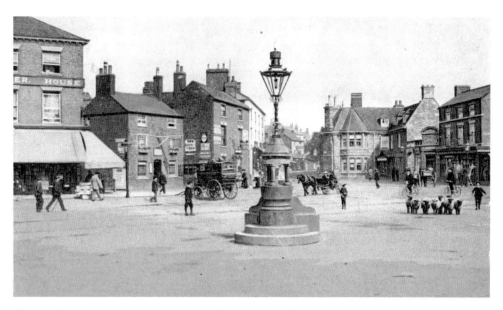

The Market Square, Market Harborough, leading to St Mary's Road and out to the railway station. A flock of sheep are being driven through the square, a passenger coach is parked on the left. The Peacock is at the junction of the Market Square and St Mary's Road. The landlord of this hotel was Mrs Harriet Marsh.

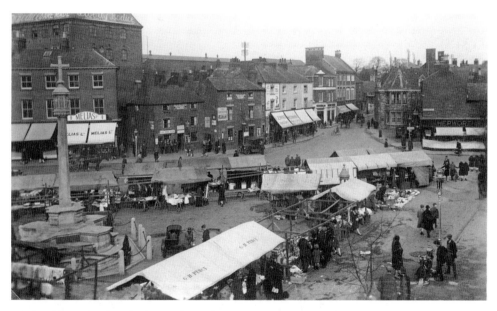

Market Day at Market Harborough on The Square in the 1920s. The war memorial was erected in 1920, and The Peacock is situated in the background on the right. The landlord is Jonathan Heggs. To the left, high in the background in front of Melias Ltd general shop, is Symington's corset factory, manufacturing the Liberty Bodice. Further along the highway is The Cock Inn, 4 The Square. The licensee is Mrs Florence Webster. The shop at number 3, by The Cock Inn, is run by Harry Jennings. With the visiting stall holder G. H. Percy situated in front of the war memorial.

An interesting Victorian bedroom suite on display in the museum in the summer of 2002 at Market Harborough.

G. Jarman & Sons' advertisement for 1922 as builders and plumbers; bedroom features like the one detailed above would be phased out.

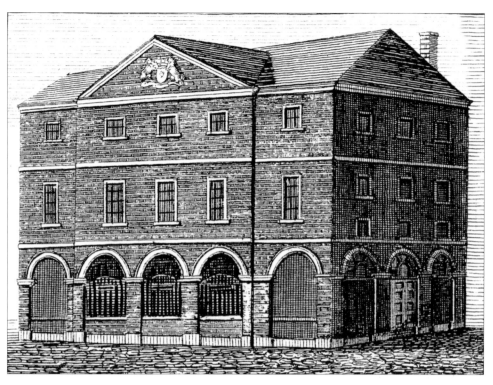

An engraving of the Town Hall, Market Harborough, in 1792. This was built at the expense of Reverend the 4th Earl of Harborough in 1788.

The Council Offices and Public Baths on Northampton Road, *c.* 1910.

FOR GOOD, USEFUL, & FASHIONABLE

DRAPERY OF EVERY KIND,

GO TO

H. HUCKETT,

CHEAPSIDE, MARKET HARBORO.'

A LARGE VARIETY OF READY-MADE CLOTHING ALWAYS ON HAND.

An interesting advertisement for 1880; it would seem H. Huckett could manufacture every type of clothing required in Market Harborough.

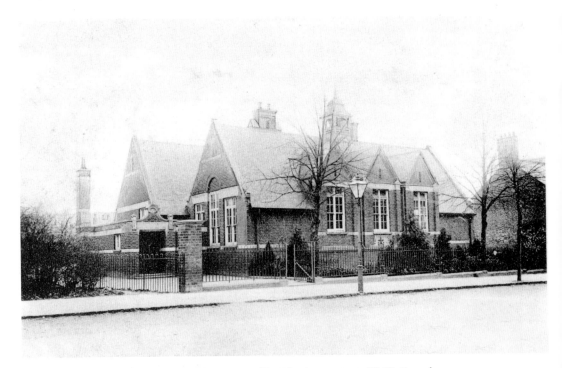

The school, Market Harborough, in 1905. The Headmaster was W. W. Grundy.

The Cottage Hospital, Coventry Road, Market Harborough, 1923. The matron was Miss Bond, the secretary Miss Hubbard, and the treasurer George Green JP.

An advertisement for the All Wool Stores Ltd, 5 Adam and Eve Street, Market Harborough, in 1922.

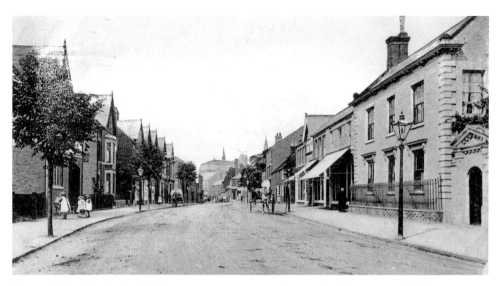

St Mary's Road, Market Harborough, 1905, with the King William IV public house centre background. The landlord was Frederick Wright.

Tel. No. 29

J. W. & A. NEWCOMBE,

House, Land & Estate Agents,

St. Mary's Road, Market Harborough.

HOUSES and SHOPS

TO LET and FOR SALE

Management undertaken of House Properties and Estates.
Agents to the ROYAL Insurance Co. Ltd.
All classes of Insurance effected.

◇ ◇ ◇ ◇

THE NEWCOMBE ESTATES CO., LTD.,

FOR SALE.—FARMS AND RESIDENTIAL PROPERTIES; also
BUILDING LAND in good positions, suitable for
Works or Residential purposes, at Market Harboro',
Luton, Coventry, Birmingham, Weston-super-Mare,
London (Mill Hill and North Finchley).

J. W. & A. Newcombe's advertisement for 1922. During the two world wars, expansion of large urban development in market towns such as Market Harborough commenced. This company promoted themselves as estate agents, rare in the 1920s yet commonplace today.

Above and right: On this page are two photographs of a house constructed between the two world wars: Moira Cottage on Coventry Road, Market Harborough. The top photograph illustrates the front of the house, while the bottom photograph has been taken in the garden at the rear of Moira Cottage.

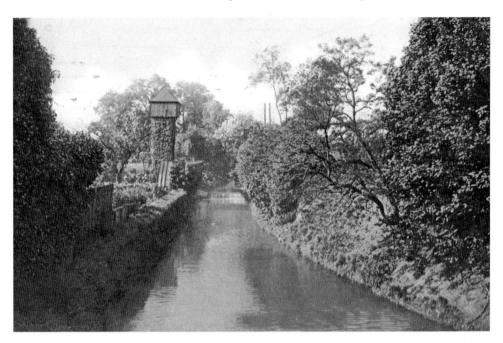

The River Welland, *c*. 1910, with a water tower near the weir. This was the county boundary until the Local Government Act became law in 1894. Part of Northamptonshire, south of this river, became part of Leicestershire.

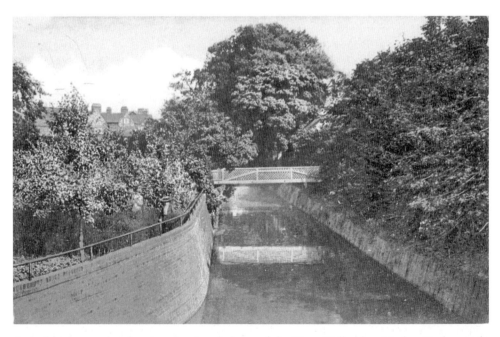

A similar view to the photograph printed above of the River Welland at Market Harborough, *c*. 1910, with the footbridge connecting both parts of the town.

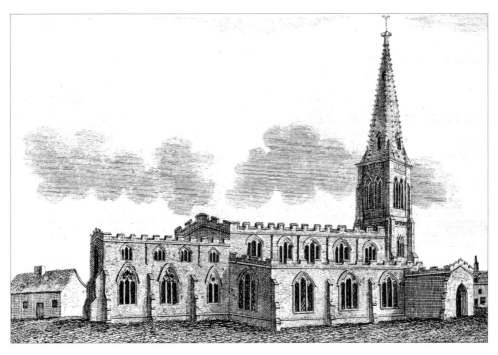

An engraving of the church of St Dionysius – *the Areopagite* – at Market Harborough, the north-east view. Drawn and engraved by Prattent 1792. Construction of this fine church commenced at the end of the thirteenth century. The steeple is considered to be one of the finest in England.

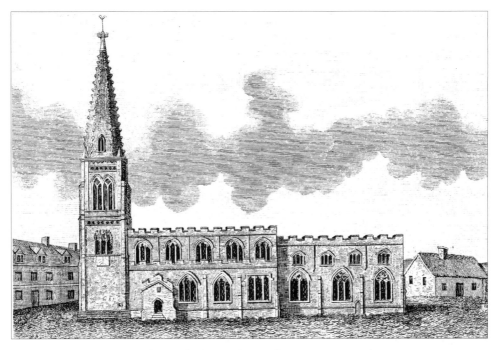

St Dionysius at Market Harborough, the south view from an engraving by Prattent 1792.

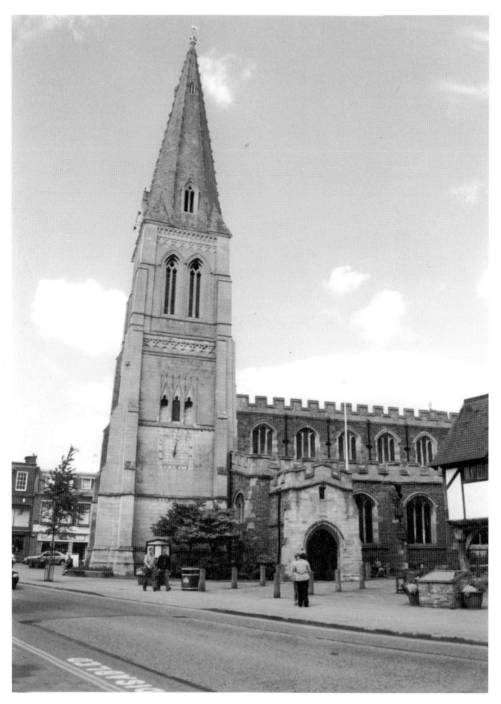

Market harborough's fine church standing high in the centre of the town in 2002, with the sundial situated on the base of the spire. In the church of St Dionysius much of the thirteenth- and fourteenth-century structure survives. As usual, the Victorians made some alterations in the 1830s and '40s.

Symington's, Market Harborough, May 2010.

The market in the square at Market Harborough in 2002.

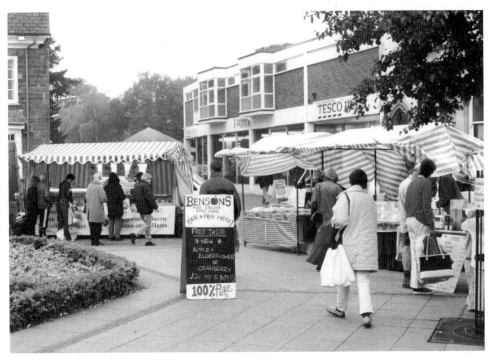

A similar view to the one published above in 2002.

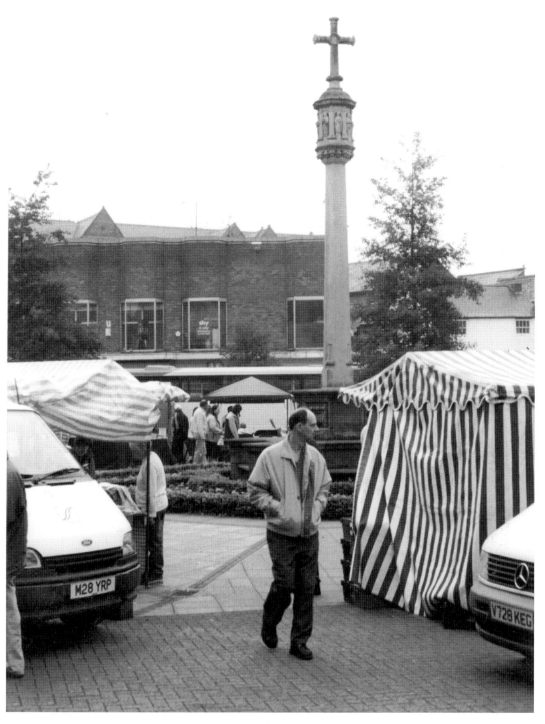

The war memorial erected in the market square at Market Harborough in 1920. It is a fine thing to visit a market in the square in 2002.

Harborough Museum, Market Harborough, incorporated into the Symington factory, May 2010.

Harborough Museum.

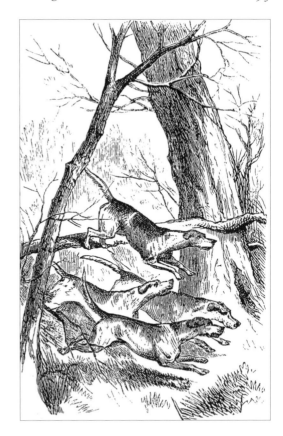

In the early twenty-first century, fox hunting is a controversial subject, but it has its place in history and generated finance in and around this town for over 150 years. This is a Surtees drawing of foxhounds hunting in a wood north of Market Harborough produced in the 1870s.

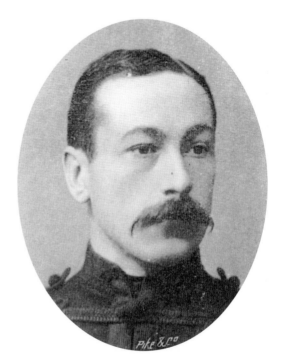

Captain Sharman Goward, living at Ashfield, Market Harborough, in 1902. Goward was an officer in the 1st Volunteer Battalion of the Leicestershire Regiment, in command of the Market Harborough Company.

The War Memorial
and Lloyds Bank,
pictured here,
dominate a thriving
town in 2002.

The centre of Market
Harborough, June
2004.

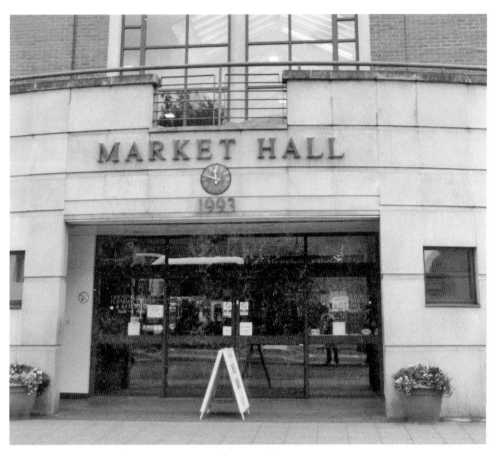

The modernisation of the market square was considered in the 1990s for Market Harborough. In 1993 the Market Hall was opened, with permanent trading sites.

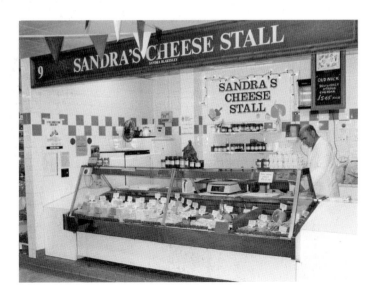

Sandra's Cheese Stall in the Market Hall, 2002.

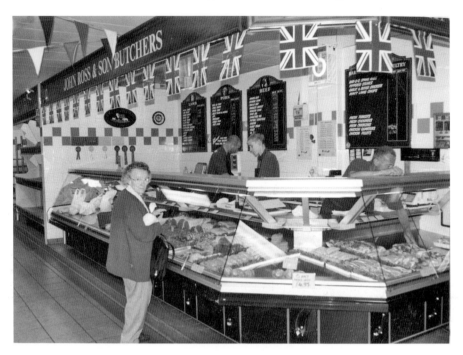

John Ross & Son's butchers' stall in the Market Hall 2002. Jo Humberston is purchasing her evening meal.

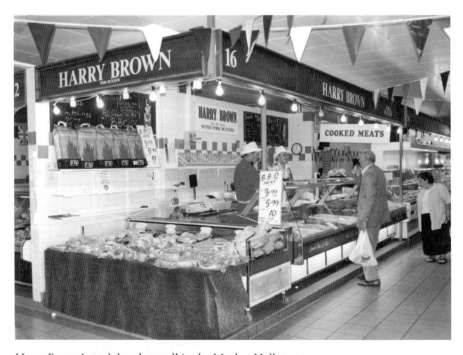

Harry Brown's pork butcher stall in the Market Hall, 2002.

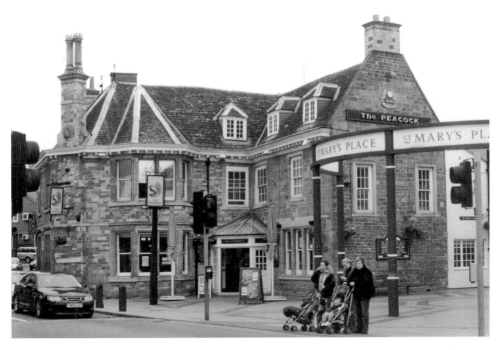

The Peacock, 15-16 St Mary's Place, Market Harborough, October 2006. This hostelry was built from stone quarried in Northamptonshire, *c.* 1700. It retains its dormer windows. It was extended in 1872 to meet the demands of the local market held in the market square and the important cattle market organised off Northampton Road. It was originally constructed to meet the extensive coaching trade and refreshment to the travelling drovers.

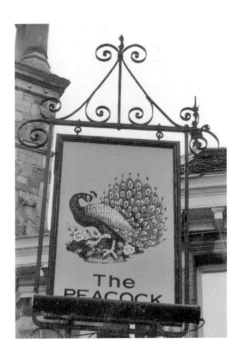

Public house sign, The Peacock, October 2006.

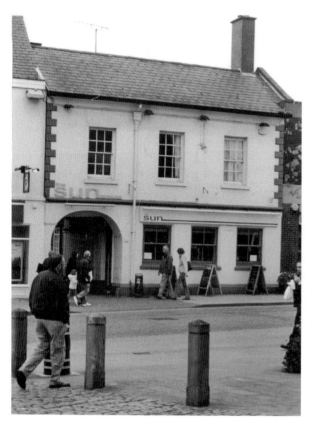

The Sun public house, 9 High Street, Market Harborough, 2006, is steeped in history; horses were stabled at the rear of the building and access was through the archway, serving the local market and a carrier every Tuesday morning – in 1846 it was Townsend & Johnson, going as far as Kettering. Simeon White was the landlord then, and was succeeded by Robert Monk in 1880, George Hutton in 1891, and William Plant in 1900.

The Nags Head public house on the corner of King's Road, Market Harborough, October 2006. This is a historic public house constructed to support the local market. In 1846 Smith Tibbs was the licensee, followed by William Pollard in 1877, William Cooke in 1891, George Patrick in 1916 and Ernest Grain in 1932.

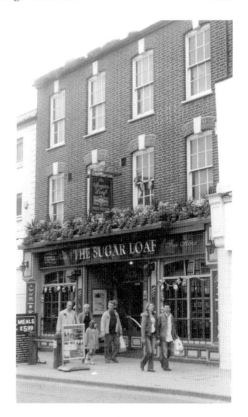

The Sugar Loaf public house, 18 High Street, Market Harborough, October 2006. A modern public house in the centre of a market town.

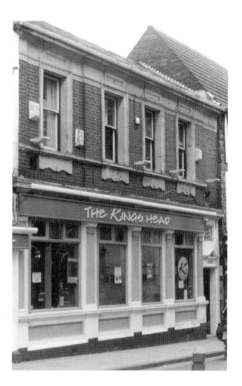

The King's Head public house in the centre of Market Harborough, October 2006.

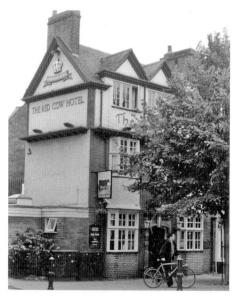

The Red Cow Hotel, on High Street, Market Harborough, October 2006. Considerable alterations have taken place on this hostelry since William Jarvis was licensee in 1846. In 1877, the licensee was John Chester, and the pub was to be taken over by his wife, Mrs Elizabeth Chester, in 1880. In 1891 Mrs Sarah Branston was licensee, followed by John Smith in 1905, Alick Smith in 1916 and William Smith in 1922.

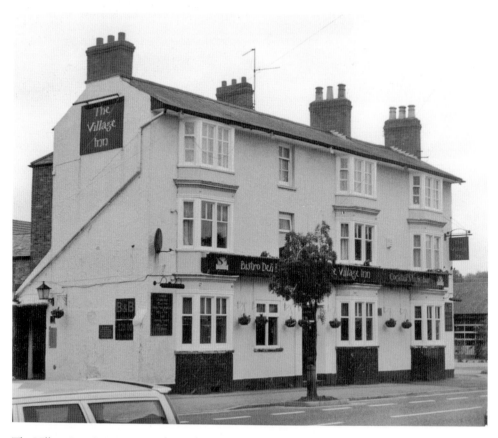

The Village Inn, St Mary's Road, Market Harborough, October 2006. Originally the Freemasons Arms, in 1846 the licensee was James Sulley; he still held the licence in 1877.

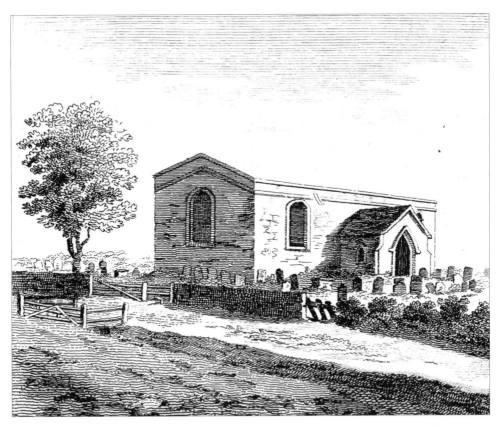

The ruined church of St Mary in Arden, off Bowden Road, Market Harborough, was constructed in 1693-4 by Henry Parmer from the remains of an earlier Norman church. The first church was damaged when the steeple fell into the centre of the church, *c.* 1660. Even though it had been rebuilt when this engraving was published on 15 June 1791 by J. Pridden, it became a ruin.

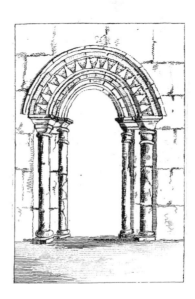

The Norman doorway situated in the ruined church of St Mary in Arden; a drawing published in 1798, from an engraving by J. Cook.

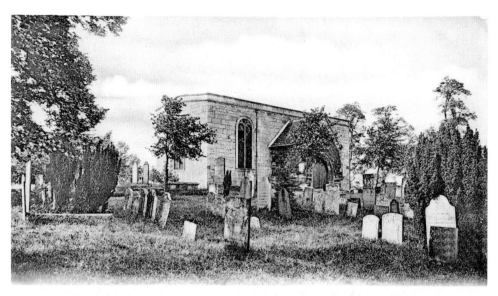

The ruined church of St Mary in Arden, Market Harborough, 1905. It is presumed that this small church pre-dates St Dionysius and did not meet the needs of an expanding market town.

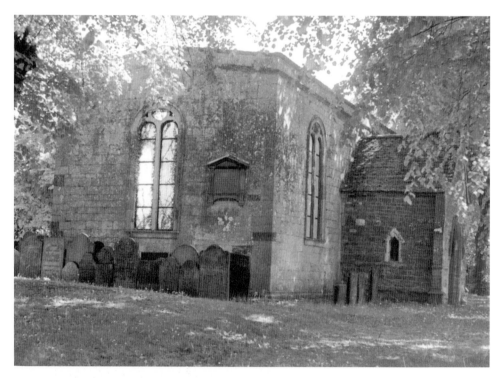

St Mary in Arden, May 2010. It was declared redundant in 1971 and vested in Harborough District Council in 1975.

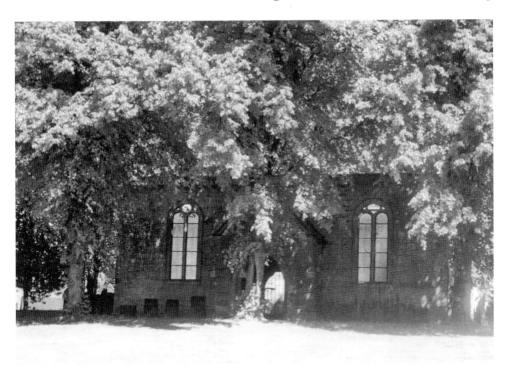

Sunlight in the church of St Mary in Arden, May 2010. The building was de-roofed in the 1950s; suggestions were made that it should be demolished in 1971.

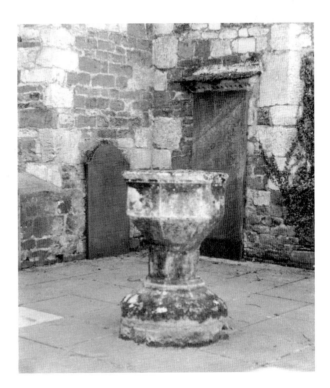

The font preserved in the centre of the church of St Mary in Arden. It was scheduled as an ancient monument in 1978.

Like Melton Mowbray, Market Harborough was involved in fox hunting, generating considerable income from the wealthy hunting fraternity visiting the town during the autumn and winter season. It is a strange comment, but fox hunters do not dislike foxes! To many, a long hunt where the fox escapes receives more support than when a fox is killed shortly after the hunt commences. Possibly this illustration of an incident near Market Harborough sums up much about fox hunting – an astute fox escaping from the hunt by swimming in the River Welland. Wise foxes enter rivers and streams to hide their scent. Foxhounds can only hunt by following a scent trail. They cannot hunt by visually sighting a fox. Here a drawing by John Leach, published in the 1860s, records just such an event.

A drawing by John Sturgess of the end of 'A hunt' in 1882.

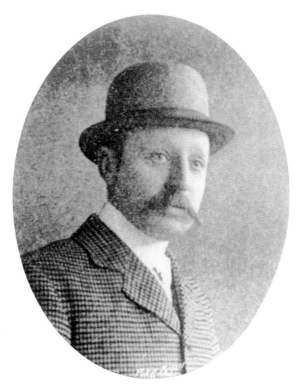

Frederick Simpkin, veterinary surgeon in 1902 situated on St Mary's Road, Market Harborough, who used to treat the hounds and hunters connected with the Fernie Hunt.

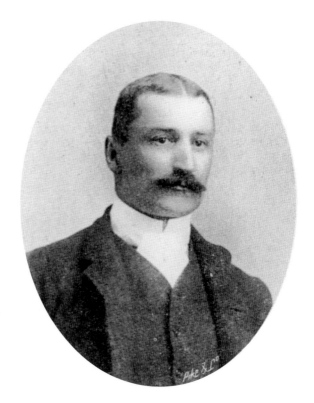

Phillip Vandeleus Beatty, who lived at The Lodge, Market Harborough, in 1902 and served in the Boer War as a lieutenant, then as a veterinary surgeon with the 14th Hussars. Vandeleus also used to hunt with 'The Fernie'.

Leicester Road, Market Harborough, *c.* 1905.

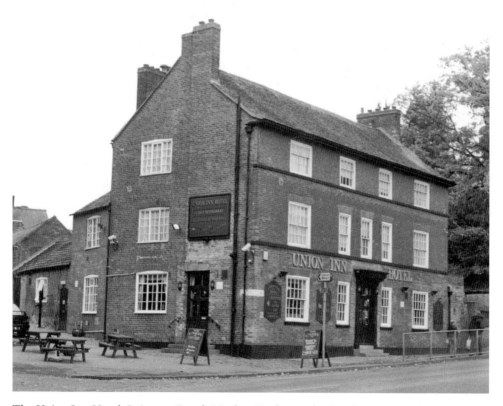

The Union Inn Hotel, Leicester Road, Market Harborough, October 2006. A late Georgian building constructed to support the nearby canal basin and wharf. In 1846 George Furnival was the licensee.

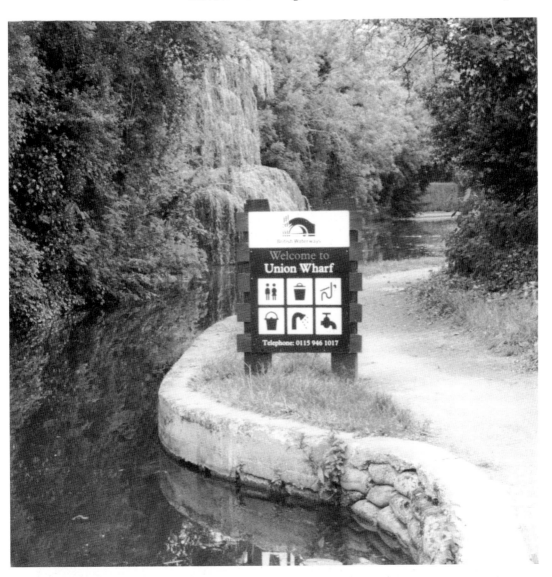

The towpath leading into the Union Wharf at Market Harborough, 2004. The canal leading to the basin at Market Harborough from the Grand Union Canal opened in 1809. The original idea was to connect Leicester with Northampton by canal via Market Harborough, to broad beam dimensions. However, the company ran out of money. Capital was raised to proceed on the Foxton length of the canal, and in 1812 the Foxton Locks were completed on narrow beam dimensions. The short length of canal to Market Harborough commences at the basin at the foot of Foxton Locks. There are no locks on the Market Harborough length.

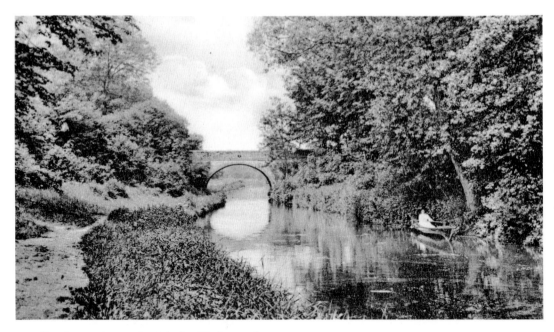

Boating on the canal at Market Harborough, *c.* 1915.

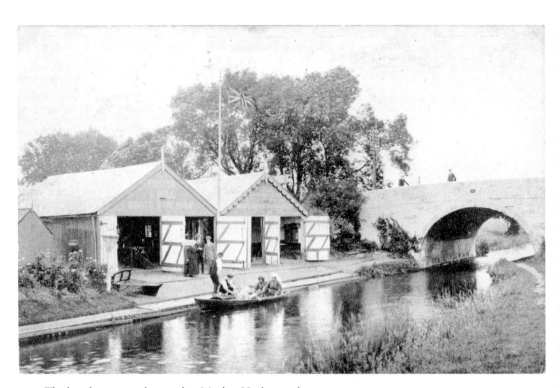

The boathouses on the canal at Market Harborough, *c.* 1920.

A very pleasant stretch of canal leading into Market Harborough, June 2004.

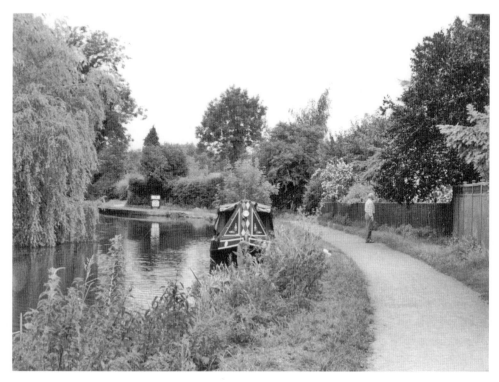

A narrowboat waiting to travel into the Market Harborough wharf, June 2004.

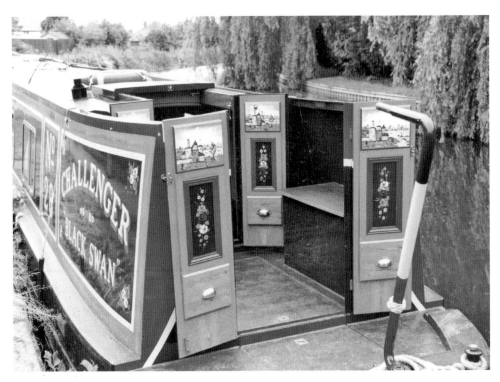

A traditional narrowboat, *Challenger Black Swan,* tied up outside the Union Wharf at Market Harborough, June 2004.

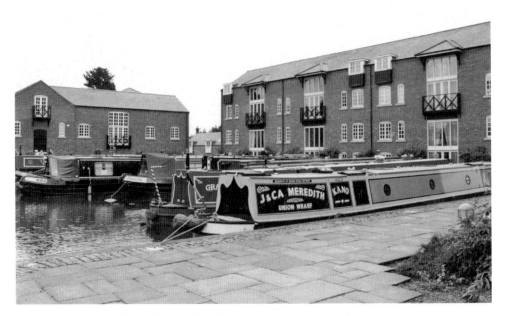

Market Harborough Union Wharf, October 2002.

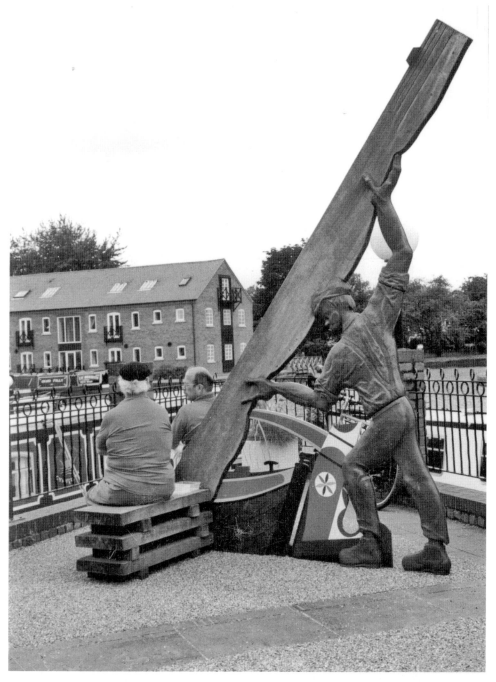

A monument to canal technology erected at the Union Wharf, Market Harborough, June 2004.

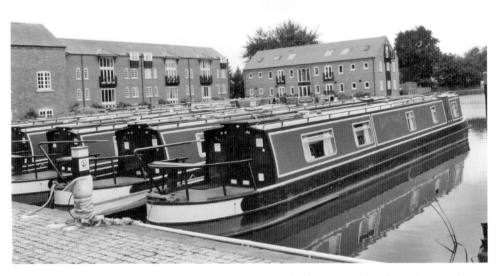

The Union Wharf, Market Harborough, June 2004. In the foreground is a line of narrowboats; in the background is a selection of modern flats.

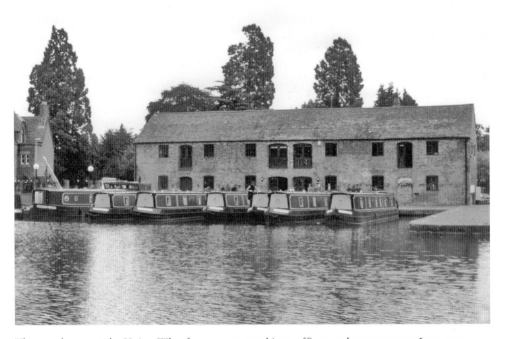

The warehouse at the Union Wharf, now converted into offices and a restaurant, June 2004.

Left: Charles I: an engraving published *c.* 1860 depicting him leaving the Battle at Naseby, south of Market Harborough in June 1645. Market Harborough was a parliamentary town. The King visited the town before the battle and returned on his way to Wistow – in defeat. As a junction town it was involved throughout the Civil War. On 8 September 1642, one of the first major encounters of the Civil War took place in Market Harborough. Prince Rupert had over 2,000 cavalry quartered in villages in and around the town. He was made aware of the fact that the Parliamentarians were storing hay for horses and quantities of supplies in the town. On the evening of the 8th he entered the town with 1,000 cavalry and a small number of troops. Several houses were plundered, hay was loaded on carts, many arms were taken and horses formed into groups to be led away. Unfortunately for Rupert, he did not make the perimeter of the town secure. Unbeknown to him a Parliamentarian soldier slipped away to the Earl of Stamford, who was camped a short distance away with 800 cavalry and many foot soldiers. Spending the night in the town, and no doubt consuming too much wine, they set out towards Leicester. Stamford laid an ambush on Gallows Hill, under cover of a spinney. It was well planned, and Rupert's cavalry and troops met a frontal attack from Parliamentarian troops who had remained well hidden, along with men from the town who wanted to retrieve their property from the rear. The surprise was complete. Thirty of Rupert's foot soldiers were killed on the spot and Rupert turned about and attempted to return to occupy the town. Houses on both sides of the highway were now well defended by Parliamentarians. Rupert fought his way through the town. He only succeeded in saving the mounted cavalry, and lost all the booty and all of his foot soldiers, who were either killed or captured. He fled eastward to the security of Rockingham Castle.

Right: A Royalist performs the awkward task of shooting from the saddle.

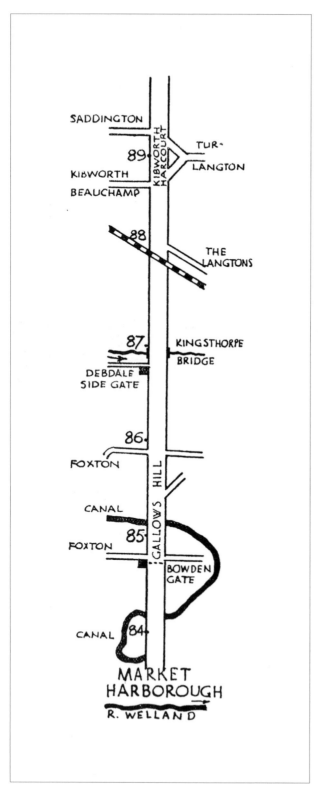

This is an illustration produced to indicate the road leading north out of Market Harborough based on seventeenth-century strip maps, updated in the 1930s; the Gartree Road leading to Leicester. It is presumed that Charles I travelled along this route to and from the Battle of Naseby. The King made Wistow Hall his base before the battle, supported by Sir Richard Halford who owned the hall and estate. Unfortunately a small skirmish took place near Wistow and a group of Parliamentarians were captured. In charge of these soldiers was Councillor Flude, High Constable of Guthlaxton hundred. The King ordered that all the captured Parliamentarians should be hanged. Cromwell never forgave the King or Halford for this brutal act. Halford escaped death, although he had to pay £5,000 to Parliament, a vast sum of money in the seventeenth century.

LITTLE BOWDEN

The district south of the River Welland at Market Harborough is Little Bowden (Bowden Parva). Until 1892 it was a separate village at a river crossing. Urban expansion took place, considered to be part of the market town. National boundary changes were undertaken; this urban area then became part of Leicestershire, transferred from Northamptonshire.

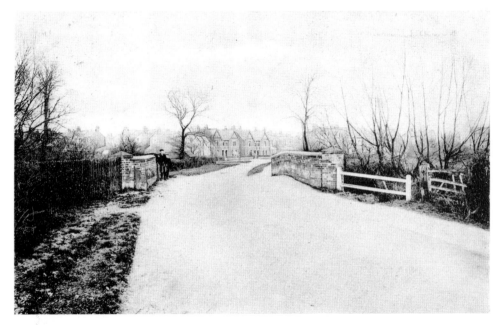

Naseby Road, in Little Bowden, a district of Market Harborough, 1905.

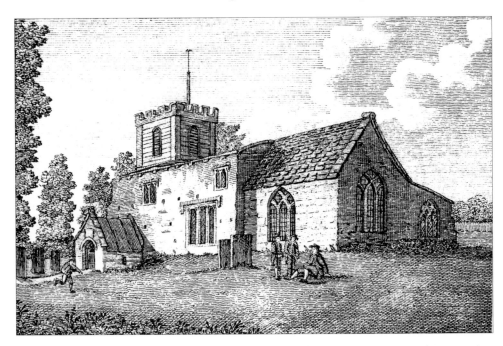

The church of St Nicholas, south-east view. An engraving by Longmate 1795. In this engraving the church has a small timber turret, very unusual in England. Constructed in the thirteenth century, the turret was possibly constructed later. On John Ogilby's strip map of 1675 a church with a tower is indicated at Bowden Parva.

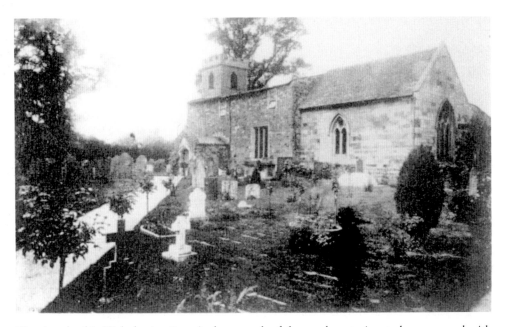

The church of St Nicholas in 1890. A photograph of the south-east view to be compared with the engraving printed above. The wooden tower has survived; it was removed in 1900 when the vicar was the Revd Thomas Frederick Jerwood BA.

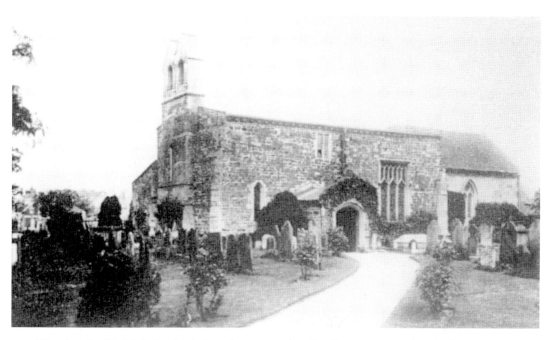

The church of St Nicholas, Little Bowden 1922. This church was extensively rebuilt in the year 1900-01, by G. F. Bedley RA, when the wooden tower was replaced by a double bellcote.

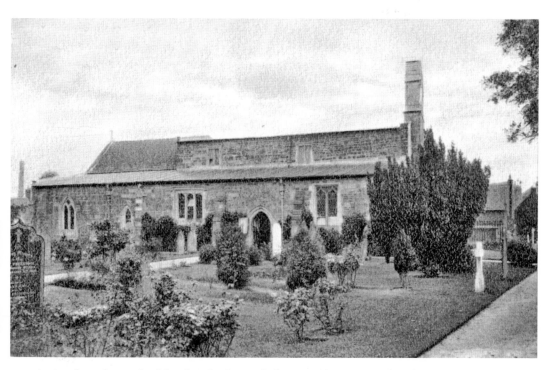

A view from the north of the church of St Nicholas, possibly in 1916 when the vicar was still the Revd Thomas Frederick Jerwood BA.

This is an interesting photograph taken in about 1920 of children fishing in the stream near the church of St Nicholas, Little Bowden, Market Harborough.

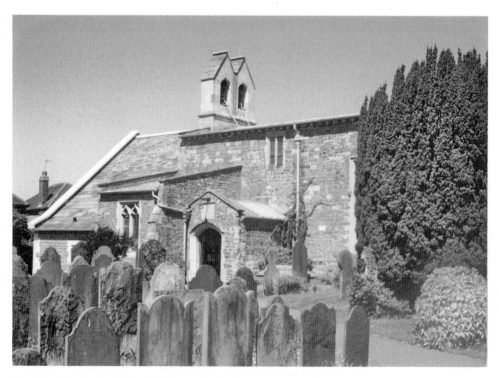

The church of St Nicholas, Little Bowden, May 2010.

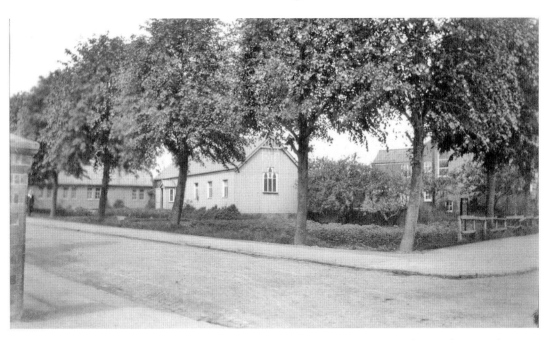

The church of St Hugh, built from brick on Northampton Road, Little Bowden, Market Harborough, between the years 1938-40 by Sir Charles Nicholson. This is a contemporary photograph *c.* 1940.

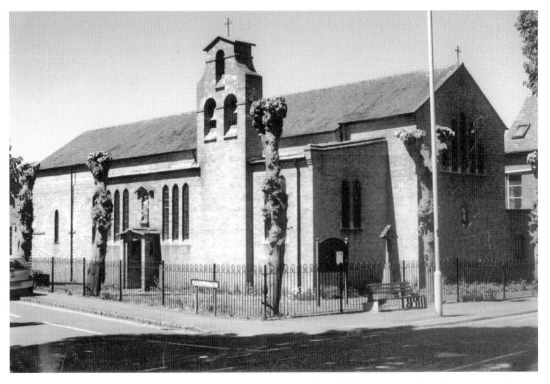

The church of St Hugh, May 2010. The parish of the Transfiguration, Little Bowden.

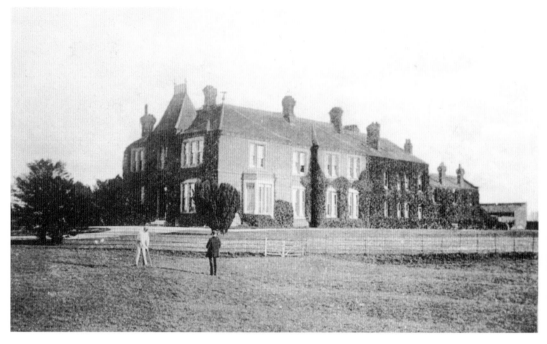

The Barn, on the hill at Little Bowden, 1902.

Edward Kennard JP, living at The Barn, Little Bowden, Market Harborough, 1902. He hunted with the Fernie and was a renowned painter in watercolours, oils and on bone china.

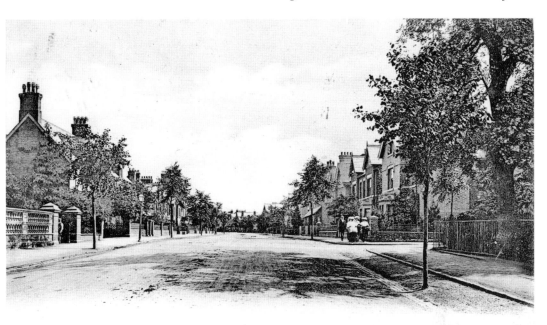

Northampton Road, Little Bowden, Market Harborough, *c.* 1910.

Thomas Hickman's advertisement for building and general house improvements, Market Harborough, 1922.

This is a photograph of Samuel Symington, 1900. In 1827 William Symington commenced dealing in tea and opened a grocer's shop. In 1850 he established a steam mill on Northampton Road, Little Bowden, Market Harborough, producing pea flower. The Symington family became some of the most influential people controlling the lives of much of the working class in the early part of the twentieth century in this small market town.

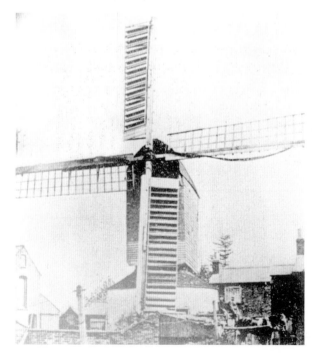

A photograph of the Windmill in Little Bowden, 1895. John Smith was the last miller. To the left of the windmill is Symington's steam mill grinding pea flour.

PATENT

PREPARED PEAS FOR SOUP;

SYMINGTON & Co.,

PROPRIETORS,

BOWDEN STEAM MILLS,

MARKET HARBOROUGH.

This food will be found invaluable for the aged, the invalid, persons with weak stomachs, and for general uses.

The process of preparing displaces all fixed air, so objectionable in the pea, It is made without boiling, is prepared in one minute, and produces one of the most nourishing and light diets.

SYMINGTON'S

DOUBLE-SHELLED SCOTCH OATMEAL.

THE PEAS IN 1d., 2d., 4d., and 6d. Packets.
SCOTCH OATMEAL, 2d. and 4d. Per Packet.

THE TRADE SUPPLIED.

An advertisement published in 1854 by William Symington promoting his pea flour, which he produced in the Bowden Steam Mills in Little Bowden, Market Harborough.

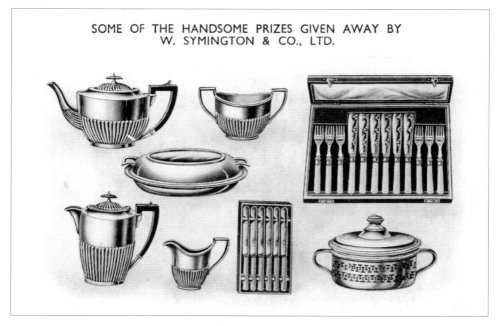

SOME OF THE HANDSOME PRIZES GIVEN AWAY BY
W. SYMINGTON & CO., LTD.

A promotional postcard issued by W. Symington & Co. Ltd. Bowden Mills, Market Harborough, with a collection of prizes you could win if you collected the correct amount of coupons supplied with tinned soup or ready meals or their cookery book, *c.* 1920.

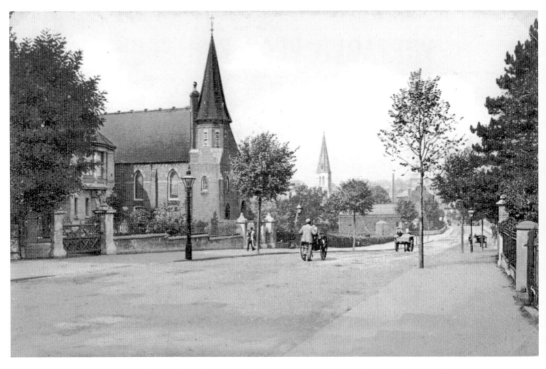

The Wesleyan Methodist Church on Northampton Road, Market Harborough, 1905. Revd Jabez Chambers was Superintendant.

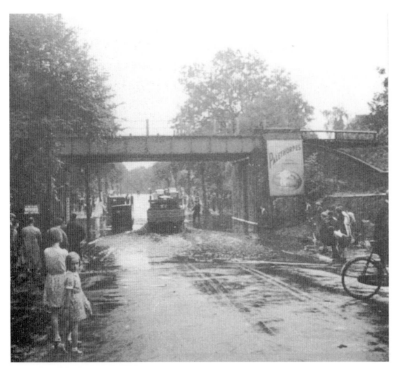

The flooded highway under the Railway Bridge, Northampton Road, Market Harborough, 1938. This bridge carried the Rugby to Stamford branch line on the LNWR.

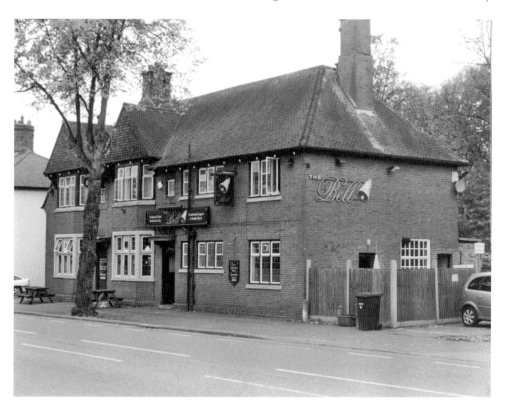

The Bell Inn, 127 Northampton Road, Market Harborough, October 2006.

The sign of The Bell
Inn, May 2010.

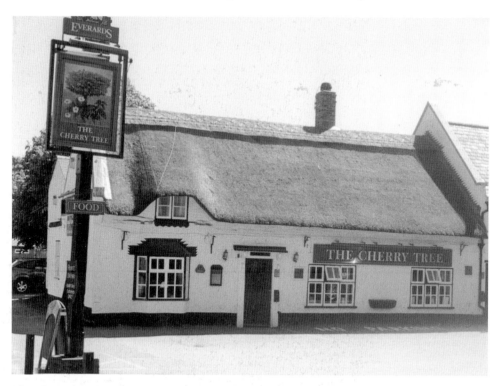

The Cherry Tree public house, at Little Bowden, Market Harborough, May 2010. In 1905 this public house was run by E. R. Maule.

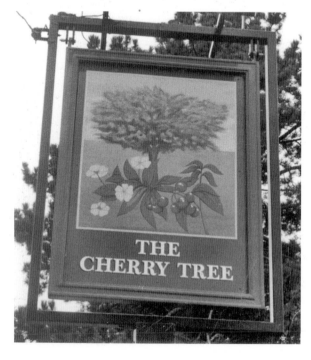

The sign of the Cherry Tree, October 2006.

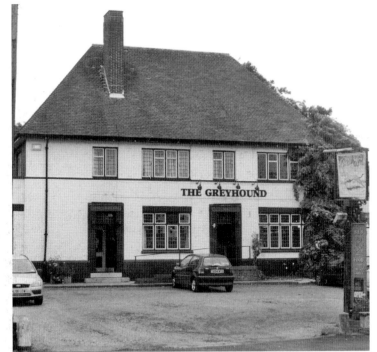

The Greyhound
public house,
31 Kettering Road,
Market Harborough,
October 2006.
An inn that has
considerable history,
John Williams was
the landlord in 1840,
Henry Barbour in
1905, and W. H.
Barber in 1922.

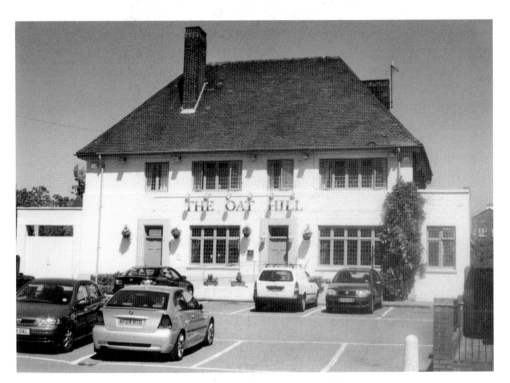

The Oat Hill, formerly The Greyhound, May 2010.

GREAT BOWDEN

In the Domesday Book of 1086, Harborough on the River Welland did not exist. The area north and south of the river was Bowden Magna, part of which was to become Bowden Parva. The two Bowdens pre-date Harborough to become Market Harborough. Before the conquest by William I this part of Leicestershire and Northamptonshire belonged to Edward the Confessor. William I granted large areas in these two counties to Countess Judith. In 1190 Henry II gave lands to Great Bowden and Harborough. He was the great-grandson of William the Conqueror. For many years Harborough had become an important crossing on the main road, supporting the local market. Market Harborough had been formed. Today, Great Bowden and Little Bowden are districts in this important Midlands town.

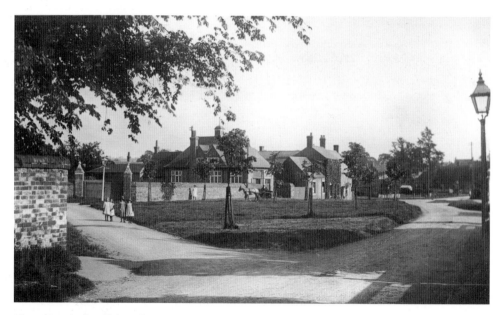

The village hall, off the village green, Great Bowden, possibly before the First World War.

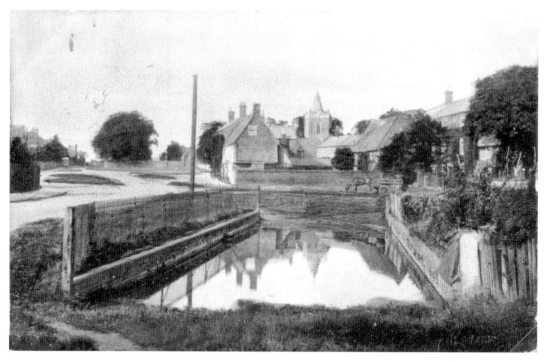

The 'wash dyke' off the village green, Great Bowden, Market Harborough, 1905. This is an area where horses and carts were cleaned and sheep were treated for ticks.

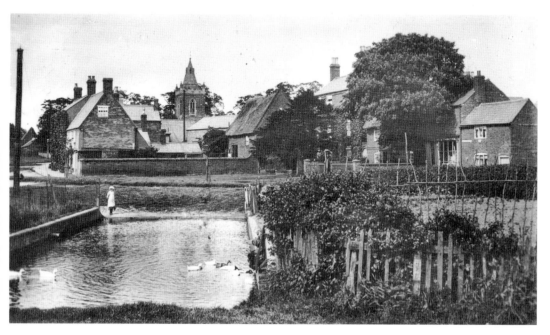

A similar photograph to the one printed above, taken a few years later *c.* 1910. Now the area of water was a duck pond.

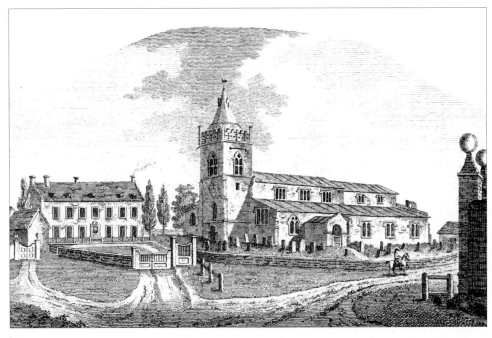

The church of St Peter and St Paul, Great Bowden. A drawing by J. Pridden, engraved by John Cary and published 15 June 1791. To the left of the church is the Rectory, with seven bays.

The Rectory, May 2010.

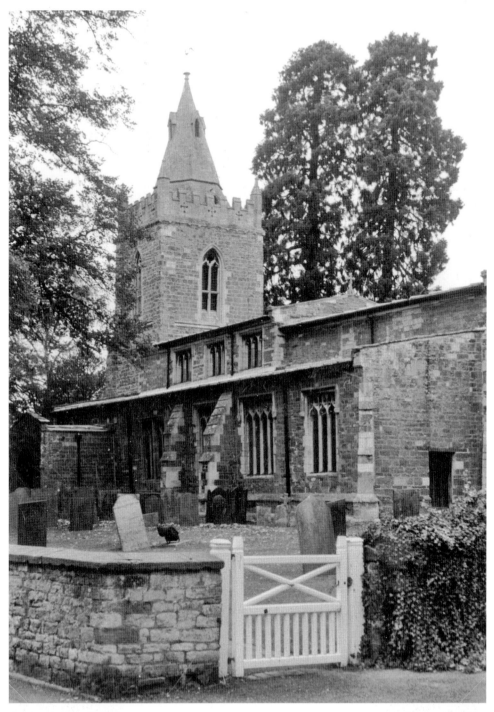

The church of St Peter and St Paul, Great Bowden, October 2006, featuring the battlements with cross slits, pinnacles, a very short spire with a few projected lucernes near the top. Fourteenth century.

Gerald Lousada, living at the Old Rectory House, Great Bowden, Market Harborough, 1902.

The church of St Peter and St Paul, Great Bowden, on Dingley Road, October 2006. Mainly a fourteenth-century building. In the chancel there is evidence of thirteenth-century work, indicating the church was virtually rebuilt a hundred years later.

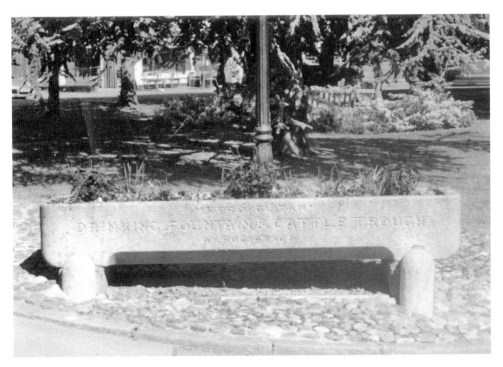

A drinking fountain and cattle trough on the village green, Great Bowden, May 2010.

John Henry Stokes, living at Nether House, Great Bowden, Market Harborough, 1902. A breeder and trainer of horses. One of his horses won the Gold cup and he trained fine hunters. He hunted with the Fernie and owned his own pack of hounds.

An engraving of Mr W. W. Tailby, who is considered to have formed the Fernie Hunt in 1856 with a pack of hounds to hunt north of Market Harborough. This hunt was formed through disagreements with the Quorn and Cottesmore hunts. In its early years it was called the Billesdon Hunt. Mr Tailby lived at Skeffinton Hall. From 1853, for three years, Richard Sutton attempted to form an independent fox hunt as Master and Huntsman. Mr Tailby appointed five separate Huntsmen until 1878, and possibly one of the most active was famous huntsman Dick Christian, of Melton Mowbray. Sir Bache Cunard took over in 1878. In the 1930s it was finally called the Fernie Hunt after one of its famous masters, C. W. B. Fernie, 1888-1919.

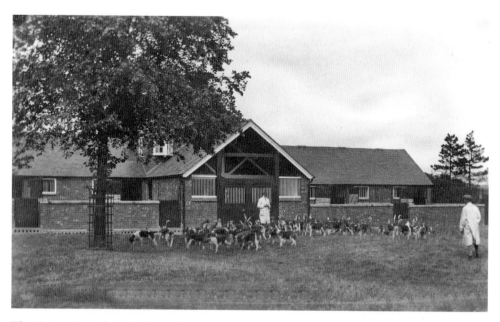

The Fernie Hounds at the Kennels at Great Bowden with Bert Peakes, the Fernie Huntsman between the years 1928-48.

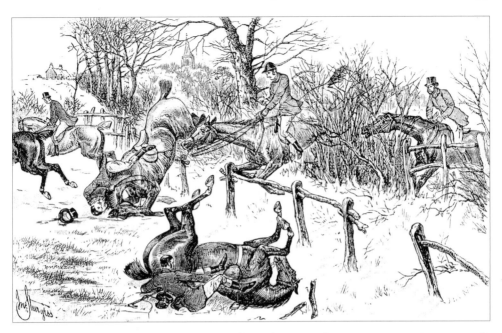

Much has been written about fox hunting, for and against the sport. In many instances a fit fox runs and gets away. Many people who hunt foxes have been killed, and horses have to be destroyed. This is a drawing by John Sturgess in the winter of 1872 that sums up the brutal sport. Unquestionably, when charging cavalry was so important in forging the Victorian empire, soldiers of the Queen were trained in war in the shire counties of England. They eventually charged to their deaths in some forgotten field in the Queen's empire.

A drawing by John Sturgess, 1880. 'After the hunt' a riderless horse is being lead away, possibly its rider is still recovering, after falling into a deep ditch.

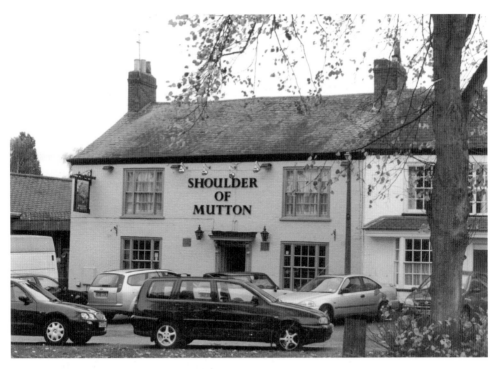

Shoulder of Mutton, 4 The Green, Great Bowden, October 2006. In 1846 James Knowles was the inn keeper; Mrs May Dexter, 1880; Jonathan Saddington, 1905; Herbert Thomas Wells, 1922.

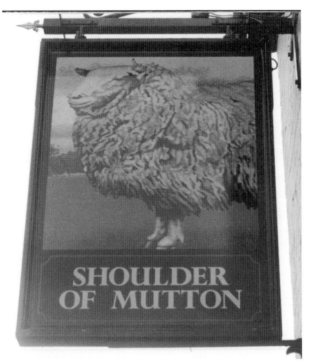

The Shoulder of Mutton pub sign.

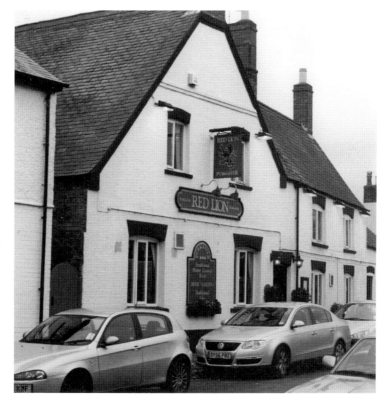

The Red Lion Inn, 5 Main Street, Great Bowden, October 2006, with a 'Red Lion'. In 1846 William Lawrence was the landlord; 1880, John Burditt; 1905, Arthur Hasnip; 1922, Thomas C. Giles.

Red Lion, the twenty-first sign, May 2010.

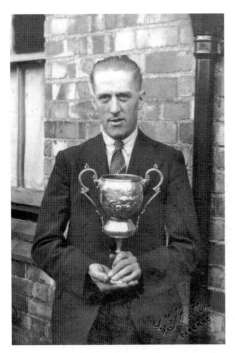

The leading sport in the Midlands was fishing in the numerous canals and rivers stretching throughout the East Midlands and on to the 'Drains' in the Fenland of Lincolnshire and Cambridgeshire. Today it is still the leading national sport. During the nineteenth and the first half of the twentieth century, the majority of the male workforce living and working in the urbanised towns and villages in the Midlands took up fishing as a hobby. Sitting in the clean countryside, away from the fumes of the industrial towns, was encouraged by many employers. One such employer was James Symington & Sons; this company had built a large hosiery factory in the centre of Market Harborough in 1884. They supported their employees and individuals from hosiery factories and other local trades to form a fishing club supported by Symington finance. In this photograph, Hugh Tebbutt is holding the Symington Cup; he worked in the hosiery trade in Fleckney before the Second World War.

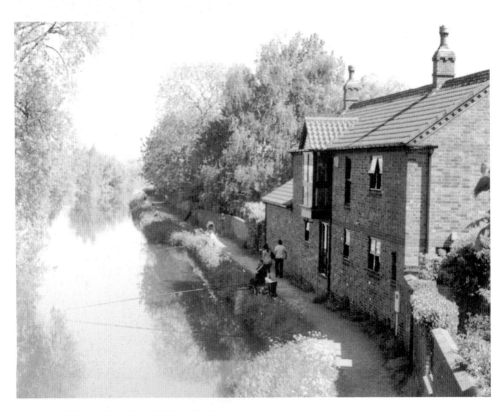

The wharf, Great Bowden. 'Fishing!' May 2010.

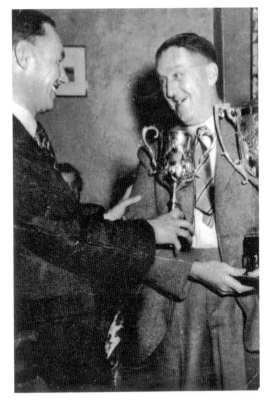

Hugh Tebbutt lived in a cottage opposite the Red Lion on Main Street, Great Bowden, after the Second World War. Hugh was the man to beat in the local fishing club. He was champion for many years and in this photograph he is being presented with the Symington Cup once again – he also won the national cup. He fished the Welland, the Grand Union Canal and took part in matches on The Drains in Lincolnshire and Cambridgeshire. The Tebbutts were a local family and in 1846 Thomas Tebbutt was the licensee of The Britannia Inn, situated at the Wharf, near Great Bowden Hall on the Grand Union Canal. Hugh's connection with canals goes back through many generations.

Hugh's cottage, May 2010.

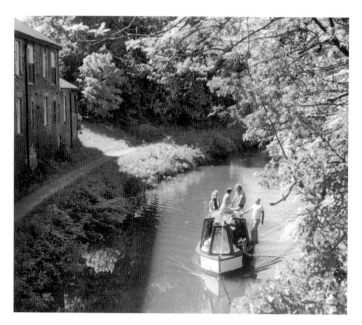
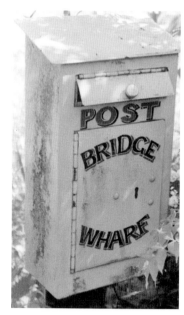

Above left: The wharf at Great Bowden on the Grand Union Canal, May 2010.

Above right: The 'un-used' post box on the deserted wharf site, off the Grand Union Canal, near Great Bowden, May 2010.

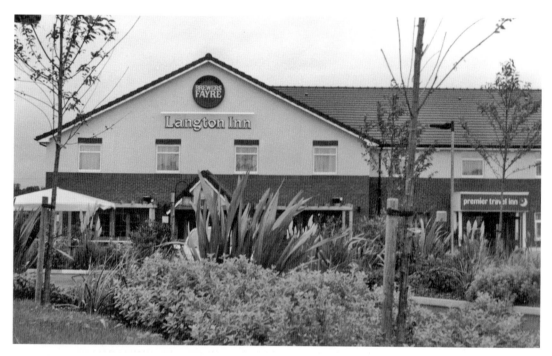

The Langton Inn, a very modern public house and restaurant situated on Melton Road, north of Great Bowden near West Langton, October 2006.

AROUND THE LANGTONS

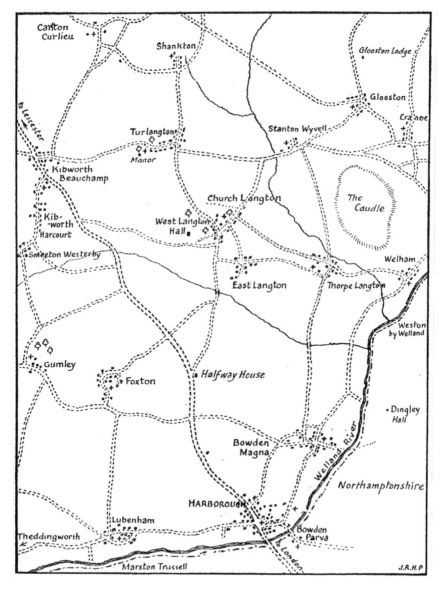

A map drawn by John Prophet in 1982 of the Langtons in the eighteenth century.

KIBWORTH HARCOURT

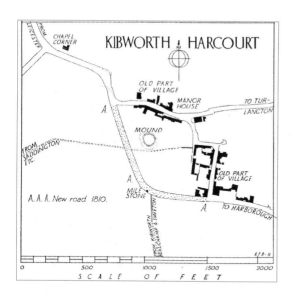

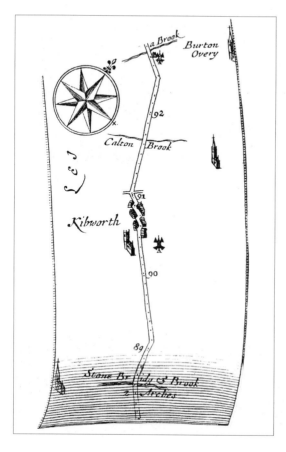

Above left: A plan of Kibworth Harcourt drawn by Percy Russell in 1934. He was the leading authority on the Gartre Road, the Roman road passing through south Leicestershire.

Above right: Sir Charles Hayes Marriott JP, DL, FRCS Lond. Living at Harcourt House, Kibworth Harcourt, 1906. The leading surgeon at Leicester Infirmary, he specialised in abdominal surgery.

Left: The London to Leicester road passing through 'Kibworth'. A section of a strip map from Ogilby's *Britannia* of 1675.

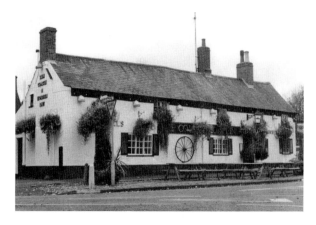

The Coach & Horses public house, 2 Leicester Road, Kibworth Harcourt, October 2006. Constructed in the eighteenth century to support the coaching trade. The landlords were John Woodford, 1846; Charles Edward Bolton, 1880; A Mattock, 1905; G. F. Knapp, 1922.

The Coach & Horses.

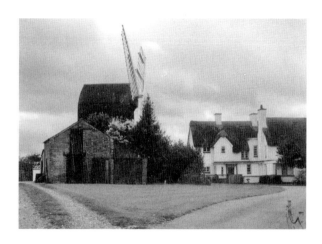

The Windmill at Kibworth Harcourt. A post mill, October 2006.

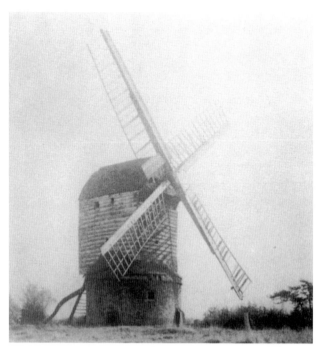

Kibworth Harcourt post mill 1924. The central post is dated 1711; possibly this is when it was installed. A post mill was recorded on this site after 1609 and by 1635, when it appears on the Merton College, Oxford, estate maps. It would seem it is an early seventeenth-century post mill, unique in Leicestershire. Owners and millers are recorded: William Fellows 1794; T. Smith, 1837; L. Smith, 1851; I. Wells, 1866; W. W. Smith, 1880. In 1916 Mrs Elizabeth Smith is recorded as the owner, employing a miller. It had ceased working by the end of the First World War. It was restored in 1936 and a restoration programme has been maintained.

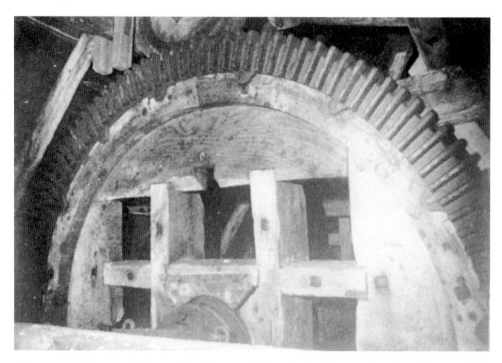

It is not a working windmill; as a historic record it is maintained in sound order with remarkable machinery but is not open to the public. This photograph was taken in 1978 of the tail wheel, clearly illustrating the iron teeth travelling on the wooden rim of the tail wheel that powers the dresser drive.

KIBWORTH BEAUCHAMP

The church of St Wilford, Kibworth Beauchamp, an engraving by Longmate published in 1798. Near the church stands the imposing rectory built by Revd James Norman BD in 1788. The vicar at the time this illustration was published was Revd Jeremiah Goodwin MA. In this illustration farm labourers are taking refreshments, while gathering hay. A beer cask lies near the group of two girls and a boy, while one leans on the stile.

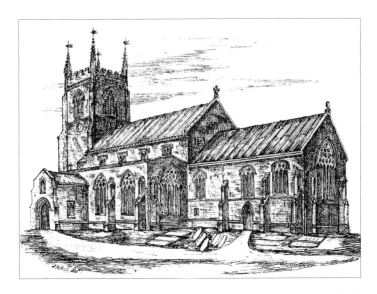

The church of St Wilford, Kibworth Beauchamp, the south-east view drawn by John Harwood Hill in 1864. The medieval tower and spire collapsed in 1825. A comprehensive rebuilding programme took place to designs by William Flint of Leicester, to be completed during the years 1832-36, without a spire.

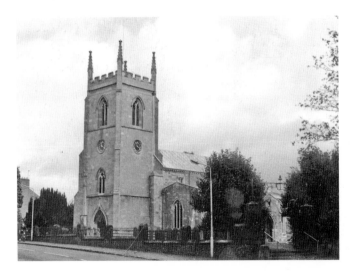

Above left: The church of St Wilford, Kibworth Beauchamp, October 2006. The priest's doorway is thirteenth-century. This church is in the main a Victorian building; many improvements have been undertaken after the disaster of 1825.

Above right: St Wilford, high on the wall at the church of St Wilford, Kibworth Beauchamp.

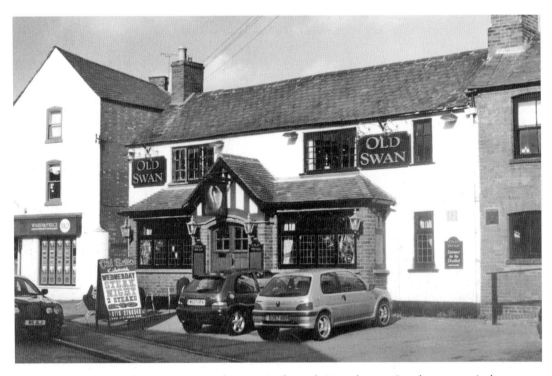

The Old Swan public house, 5 High Street, Kibworth Beauchamp, October 2006. A three-hundred-year-old coaching inn. Charles Watts was the landlord in 1846; William Fletcher, 1880; and Tom Coleman in 1905 – he was still in charge in 1922.

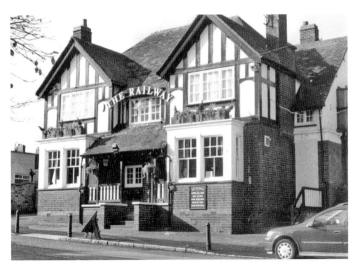 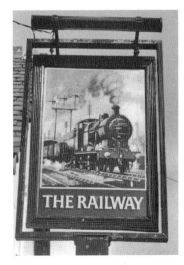

Above left: The Railway, 6 Station Street, Kibworth Beauchamp, October 2006. Built on the site of a row of cottages, after the railway station was opened on 8 May 1857, as the Railway Arms. George Randall was the publican in 1880. Edward Peperdy took over in 1891; he was still the licensee in 1905. In 1922 Leonard Arthur Boniface held the license.

Above right: The Railway after the station was closed on 1 January 1965. The site was eventually cleared and developed, and a new name was introduced.

Station Road, Kibworth Beauchamp, 1941. On the right is The Railway Arms public house. The licensee was Louis Joseph Wyatt.

CARLTON CURLIEU

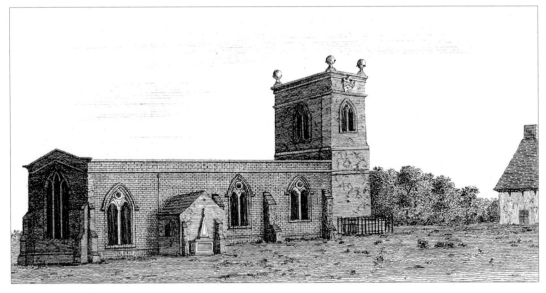

The church of St Mary, Carlton Curlieu, the north-east view. An engraving published in 1798. The tower is of Norman design. The date 1685 is incorporated in the design at the top of the tower; possibly the architect was Henry Dormer.

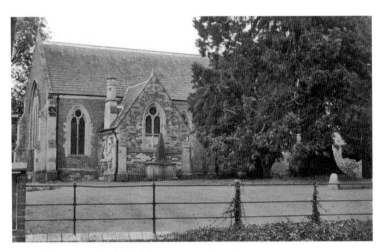

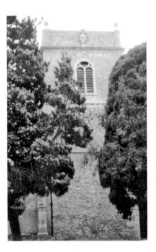

Above right: The tower of St Mary featuring the parapet on the tower with four balls instead of pinnacles, September 2006.

Above left: The church of St Mary, in a group of trees. Compare the stone vestry extending from the church with an obelisk erected in front of the structure indicated on the engraving printed above with the photograph of 2006. Dedicated to William Fenwicke in 1753.

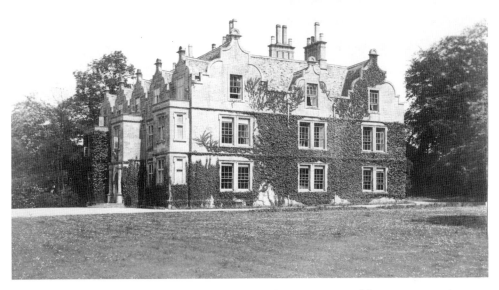

Carlton Curlieu Hall in 1905. It was constructed on the instructions of the estate owner in 1621, by John Bale. A fine Elizabethan-style building, it was the home of John Stewart in 1905.

The main street, Carlton Curlieu, 1905. The post office was on this street, and the sub-postmistress was Mrs Ruth Coleman.

CHURCH LANGTON

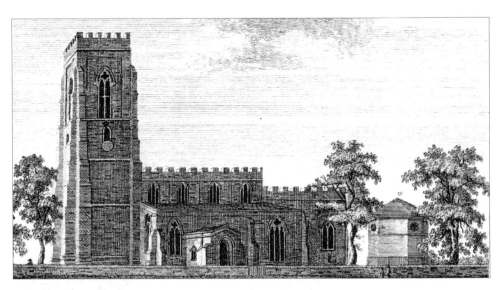

The church of St Peter, Church Langton in 1797. The rector is William Hanbury MA. This engraving was published by J. P. Malcolm.

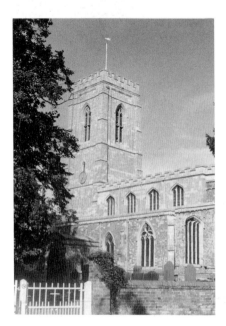

The church of St Peter, Church Langton, September 2006. The tall tower is well illustrated in this photograph. A thirteenth-century building with many Victorian alterations.

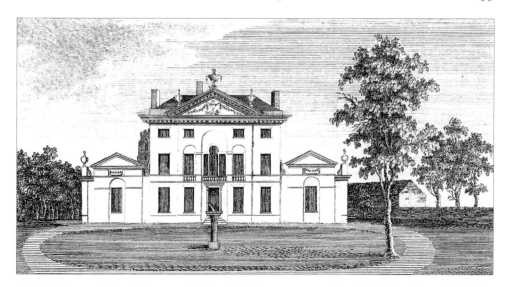

The Old Rectory, Church Langton. William Hanbury commenced building this rectory during the year he died, 1778, to be completed by his son in 1786. This engraving was published in 1798.

William Hanbury MA, 1725-78. A forward-thinking parson. He attempted to form a charitable trust to further Christian thinking throughout England. He related this to the countryside. He started extensive commercial nurseries at Gumley and Tur Langton. One of his far reaching ideas was to construct a collegiate church, to include a vast library, printing department, a museum and observatory, a music school, an experimental garden and a country hospital. He died in his early fifties with most of his ideas unfulfilled. 'A man before his time'.

Above left and right: The Hanbury School at Church Langton, September 2006. Founded by William Hanbury, 1725-1775.

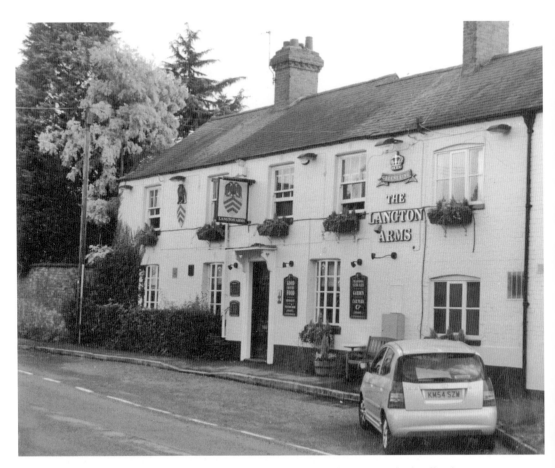

The Langton Arms, Main Street, Church Langton, September 2006. The landlord in 1905 was Charles William Hardy.

SHANGTON

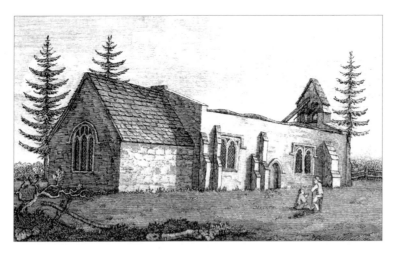

The church of St Nicholas Shangton, north-east view, an engraving drawn by Longmate, published in 1793. This small church was possibly constructed in the late twelfth or early thirteenth century. It would seem to have had a higher roof, incorporating the window retained with lengths of wood.

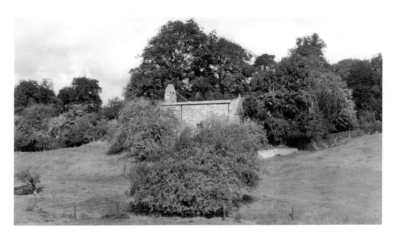

The church of St Nicholas in the fields at Shangton, September 2006. An extensive rebuilding took place in 1863. The flat roof was retained and the odd window has been supported with metal supports. Possibly there was a plan to incorporate a bell in the window space.

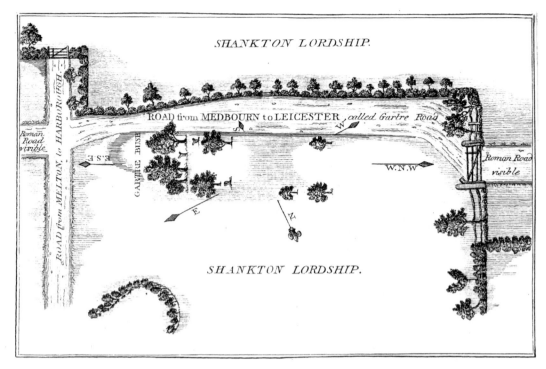

An illustration of the 'Gartre Bush' produced by John Tailby and engraved by Longmate, 1797. In the Shangton parish, the site can be located east of the 'Care Village' on the B6047 at the road junction, leading to Melton Mowbray, crossing the Gartre Road.

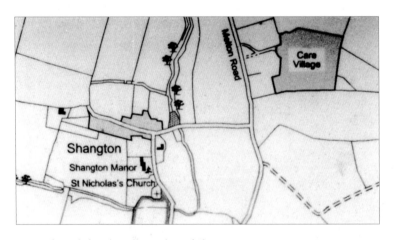

Above left: The village plan of Shangton.

Above right: The Norman font in the church of St Nicholas, Shangton, September 2006.

TUR LANGTON

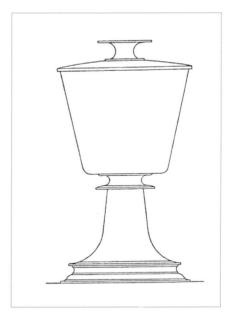

Above left: The church of St Andrew, Tur Langton, September 2006. This is a modern church constructed during the years 1865-66. A Victorian building designed and built by H. Goddard & Sons, to replace the church that fell into a ruin to the north of the village.

Above right: A silver cup and cover paten donated to the church of St Andrew, Tur Langton in 1634, total weight 8.9 ozs.

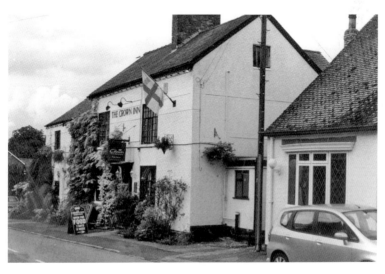

The Crown Inn, Main Street, Tur Langton, October 2006. The licensee in 1880 was Charles Cooper, who also traded in cattle. In 1891 the publican was Henry Pitts; in 1905, Samuel Cox.

STONTON WYVILLE

The church of St Denys, Stonton Wyville, the north-east view. A drawing by Schnebbelie, engraved by John Cary 16 September 1791. The rector in 1797 was Thomas Reid MA.

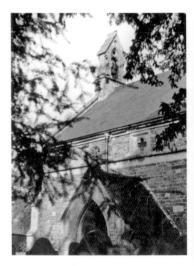

Above right: The church of St Denys, Stonton Wyville, September 2006. A thirteenth-century building, the Victorians made considerable alterations; in 1869 J. Goddard designed and constructed the small bell tower.

Above left: Edmund Brudenell's tomb-chest of 1590, situated in the church of St Denys, Stonton Wyville.

WEST LANGTON

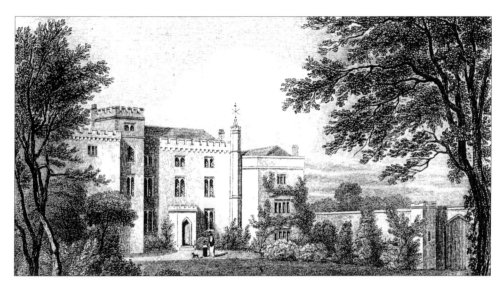

West Langton Hall, a drawing by J. P. Neale, engraved by W. Redclyffe, published by Jones & Co. Temple of the Muses, Finsbury Square, London, 3 April 1830. Constructed during the years 1660-69. The gardens were laid out by Revd William Hanbury of Church Langton in the 1770s.

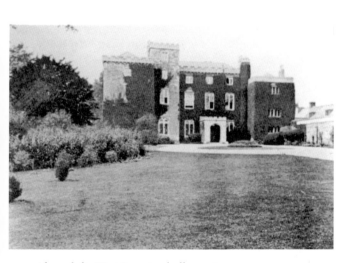

Above left: West Langton hall, 1906.

Above right: Capt. William Pochin Warner JP, living at West Langton Hall, Market Harborough, 1902. He hunted with The Fernie, Cottesmore and was Master of The Quorn for seven years. For a number of years he was a Captain in the 19th Hussars.

EAST LANGTON

Above left: The Crenelated tower converted into a private house on the Main Street, East Langton, September 2006.

Above right: Mr J. G. Kendell, living at The Grange, East Langton in 1895. He was Elected as a ecouncillor for the Kibworth Division of the County Council.

The Bell Inn, Main Street, East Langton, October 2006. In 1846 Zachariah Beadman was the landlord; in 1880 John Smith held the license – he was also a Maltster, brewing his own ale. In 1891 Thomas Faulkener held the license. In 1905 his wife was running the public house.

THORPE LANGTON

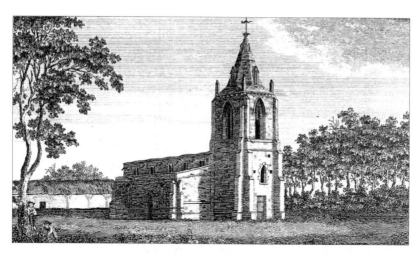

The church of St Leonard, Thorpe Langton, an engraving of the north-west view published in 1797. A late thirteenth-century building, with numerous Victorian alterations.

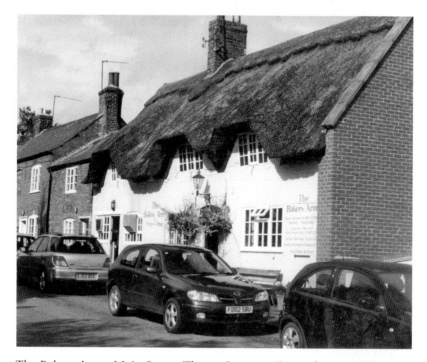

The Bakers Arms, Main Street, Thorpe Langton, September 2008. In 1846 Thomas Smith was the publican. In 1880 Vendy Matthew held the license; he was also the local butcher, grazing and killing his own cattle. In 1891 the publican was B. B. Sedgeley; in 1905 George Harding and in 1922 Richard Hand.

GLOOSTON

Above left: The church of St John the Baptist, Glooston; in the years 1866-67 this church was re-built under the direction of H. Goddard & Son. In 1867 John Harwood Hill recorded the completion of the work in this drawing.

Above right: A silver cup donated to the church at Glooston, dated 1601, weighing 4.7 ozs. There was also a silver cover paten dated 1609, weighing 1.30 ozs; on the foot of the paten is the inscription 'The parish of Koope of Glooston 1609'.

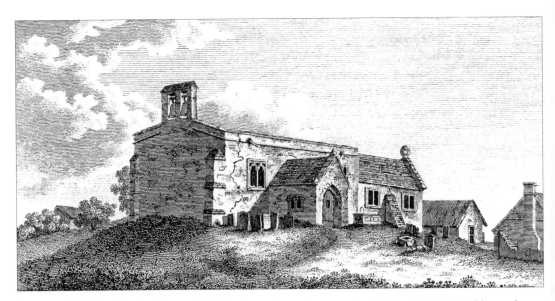

The church of St John the Baptist, Glooston, the north-west view. A drawing by J. Pridden and engraved by J. Cary, 12 July 1793. Note the small flat bell tower.

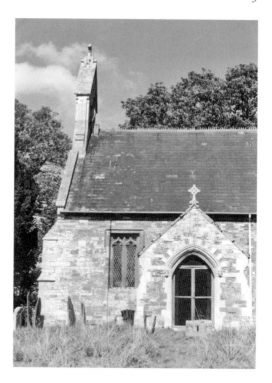

The church of St John the Baptist, September 2006. Note the more pronounced bell tower that was built in 1867.

The Old Barn Inn, Main Street, Glooston, September 2006. This is a modern name for an ancient public house that was situated in the village in 1846. The Bell was run by George Neale.

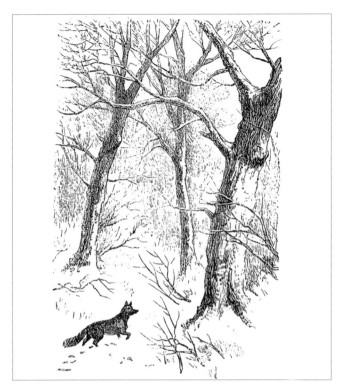

Fox hunting played an important part in village life in and around Glooston in the nineteenth century. This is a fine drawing by John Sturgess during the winter of 1874. 'A fox in Glooston Wood'.

Calling in the hounds outside a wood in 1884. Hounds enter a copse, wood or thicket where horses cannot enter. The fox flees for its life, the horsemen then follow the hounds. If the hounds cannot find a fox, or it has 'gone to earth' they are withdrawn by sounding the correct call on the huntsman's horn. A drawing by John Sturgess.

CRANOE

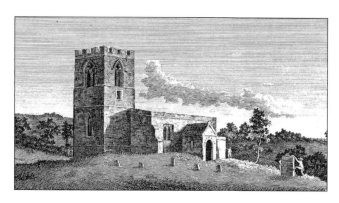

Above left: The church of St Michael, the south-west view, an engraving published in 1795.

Above right: A collection of pewter held in the church of St Michael in the 1880s; pewter cup dated 1699 with a pewter paten of the same date, inscribed Jonas R. Sonnant; pewter flagon inscribed Jonas/Durand 1699; pewter dish dated 1728 inscribed, 'Given to the parish of Cranoe by Elizabeth Countess of Cardigan'.

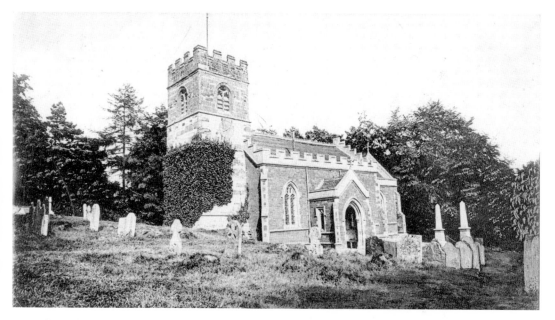

The church of St Michael, Cranoe in 1905. The vicar was Revd George Frederick Mainwaring Scott BA. There is evidence that the original church was built in the twelfth century. The surviving font appears to be Norman.

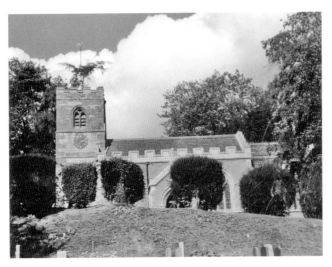

Above left: The church of St Michael, Cranoe, September 2006. The base of the tower is possibly Norman. The crenelated top is in the perpendicular style. This church was virtually rebuilt by J. G. Bland from Dingley between 1847-49.

Above right: A silver cup held in St Michael's church in the 1880s, dated 1725, weighing 4.7 ozs.

Cranoe School, erected in 1843 by the Earl of Cardigan for the use of the local children. A drawing by John Harwood Hill in 1867.

SLAWSTON

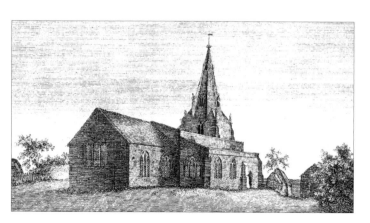

Above left: The church of All Saints, Slawston, north-east view. A drawing, engraved and published by J. P. Malcolm 1797. A thirteenth-century building with tower, the spire is fairly certain to be fourteenth-century.

Above right: A silver cup held in the church of All Saints in 1880, dated 1570, weighing 4.5 ozs.

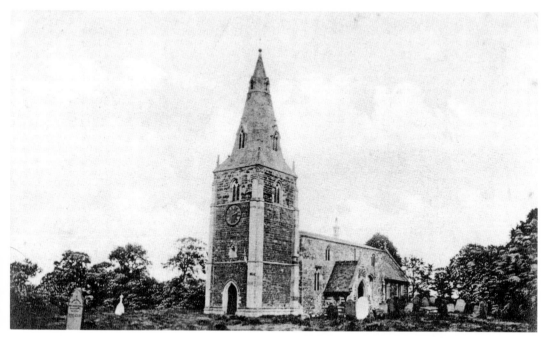

The church of All Saints, Slawston, 1905. The vicar is Revd Stephen Swetenham Browne BA. A major restoration in the building took place in 1864 under the direction of H. Goddard & Son.

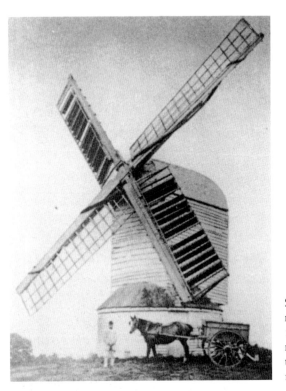

Slawston windmill *c.* 1880. A post mill stood in the village of Slawston in 1779. Possibly this is how the original mill was constructed. The wooden timbers would have to be continuously replaced; by 1884 it was out of use.

The post mill at Slawston in 1905 in a very dilapidated state. The mill had two common and two spring sails mounted on a pole end and turned by a tail pole, by hand. The round house was constructed from wood.

Slawston Windmill, *c.* 1930. The original windmill was rebuilt as a feature on the landscape. It never ground corn and could not rotate on its base, and should be considered a replica! It would seem some finance for the rebuild was provided from the Fernie Hunt. On the 29 July 1930 this 'eye catcher' was struck by lightening and was burnt to the ground. The site is still visible as a grass-covered mound.

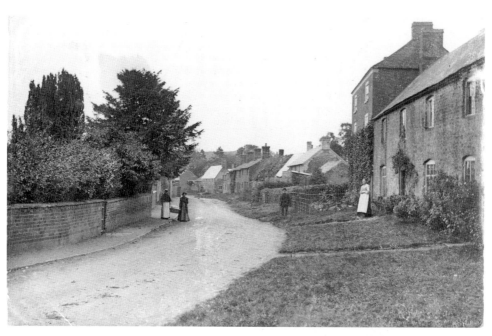

The Main Street, Slawston 1905, with the post office. The sub-postmistress was Miss Emma Marlow.

WELHAM

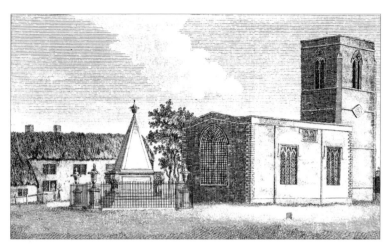

The church of St Andrew, Welham, north-east view. A drawing produced by J. P. Malcolm engraved by Longmate 1797. The vicar was Revd Edward Griffin MA. Near the church stands a free-standing obelisk to Frances Edwards, 1728. This monument was removed in 1810 and now stands in the north transept.

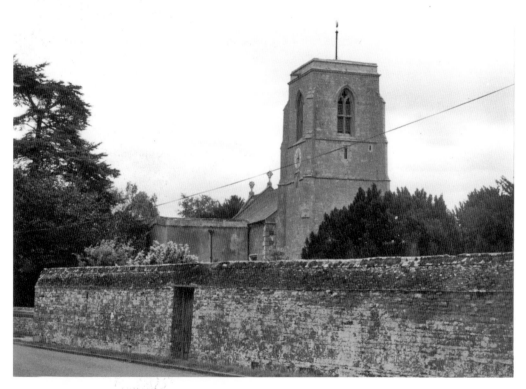

The church of St Andrew, Welham, September 2006. A thirteenth-century tower with a plain parapet; considerable rebuilding took place *c.* 1720. Throughout the early part of the nineteenth century many alterations on the building took place.

OUT TO 'EYE BROOK'

Eye Brook rises out of the southern ridge of Tilton-on-the-Hill, draining through the Leicestershire countryside. The reservoir lies below Stokerston, leading out to Caldecott in Rutland. This reservoir was built by Stewarts and Lloyds to supply water to their steel works in Corby, completed in 1940. The Eye Brook is also the boundary between Leicestershire and Rutland. This expanse of water is a haven for wild fowl. Lay-bys have been built off the highway at regular intervals to enable visitors who come by car to view this interesting expanse of water. Many roads to the east of Market Harborough lead to the reservoir, minor roads and lanes stretching across unspoilt rural England.

HALLATON

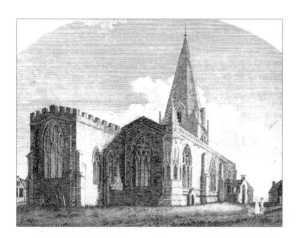

Above left: The church of St Michael, north-east view; an engraving published in 1798, it is essentially a Norman building constructed on the site of a Saxon church, with many thirteenth-century alterations.

Above right: An example of Saxon carving preserved in Hallaton church.

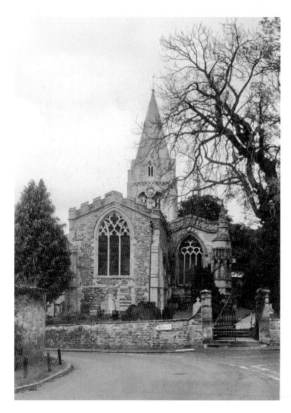

The church of St Michael, Hallaton, with its thirteenth-century spire, September 2006.

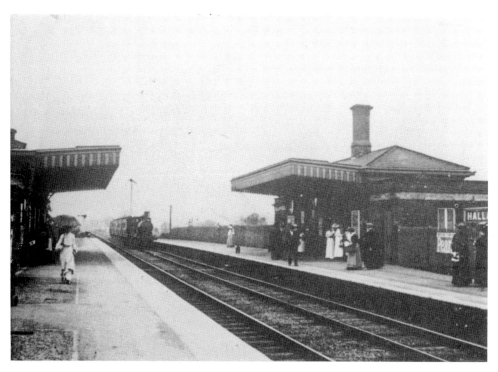

The Great Northern, London & North Western Joint Line, railway station at Hallaton, *c.* 1900. It opened on 15 December 1879, closed for passengers 7 December 1953 and finally closed for all traffic 20 May 1957.

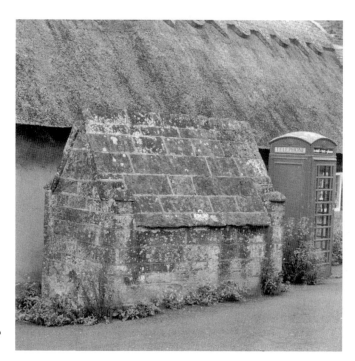

The 'Lock up', Hallaton, September 2006. These small prisons were constructed at the expense of the parish and run by the parish constable, principally to control drunken behaviour. Individuals were locked-up for the night.

The Bewicke Arms, Eastgate, Hallaton, September 2006. A notable building with a gabled wooden cross wing. The landlord in 1846 was Thomas Peck, and in 1880 he was running a farm from his licensed premises. In 1900 Henry Butteriss was running the public house. In 1905 his wife had taken over the license and was still running it during the First World War.

The Fox Inn, 30 North End, Hallaton, September 2006. A former farmhouse and brewery run by John Retty in 1846. It is one of the starting points for the annual Easter Monday bottle-kicking contest with nearby Medbourne.

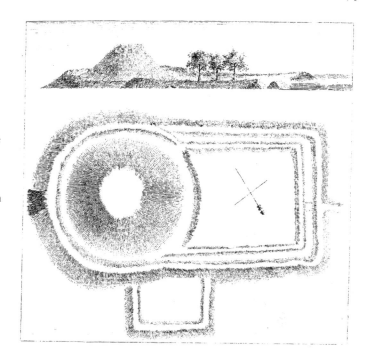

The motte-and-bailey castle at Hallaton. Drawn by C. J. Bewicke and published as an engraving on 4 September 1795. It is considered to have been constructed during the reign of King Stephen, 1135-54. No stone work has survived, the ditch is deep and the bailey is extensive. It can be reached via a footpath leading from the church of St Michael.

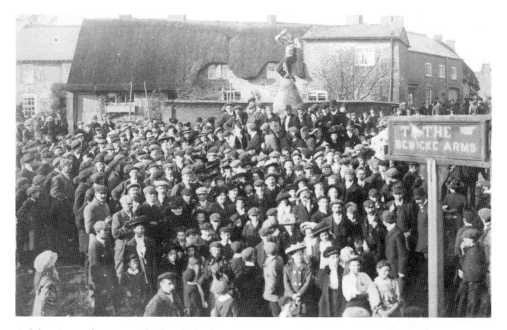

Celebrations of winning the bottle kicking contest near the Butter Cross at Hallaton, *c.* 1920. The village had successfully defended the brook between the two villages below Stowe Hill. Traditionally hare pie is distributed to the participants before the bottle kicking contest. The contestants fight for a small wooden casket of ale. The object is to carry or kick it over the local brook; there are three runs. The villagers who cross twice win. There is no limit to the number of participants. It would seem it stems from a pagan spring rite.

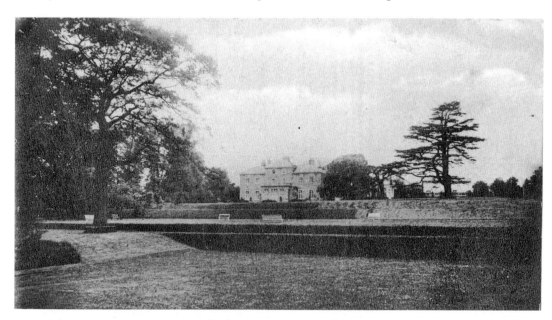

Hallaton Hall, a Victorian building. The home of Samuel Nevins Bamkart in 1905.

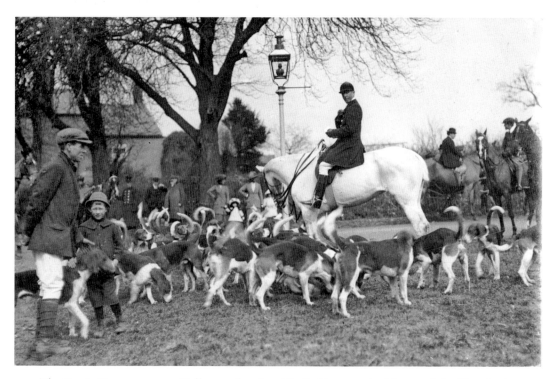

The Fernie Hunt: a meet at Hallaton when Lord Stalbridge was the Master of the Hunt in the 1920s. The Kennels were at Medbourne: they were later transferred to Great Bowden.

HORNINGHOLD

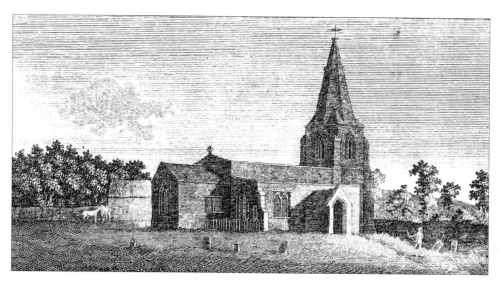

The church of St Peter, Horninghold. An engraving by J. P. Malcolm published in 1794. An early thirteenth-century building with a fine Norman doorway.

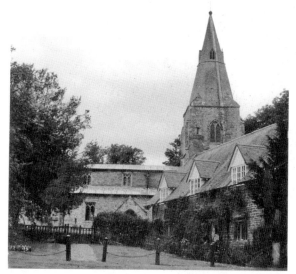

Above left: An interesting bench seat in the church of St Peter, with a tulip designed seat, possibly a Jacobean back.

Above right: The church of St Peter, September 2006. The tower and spire is considered to be late thirteenth-century. The cottages leading to the church in this photograph were constructed in 1882-3, by Thomas Hardcaste from Blaston Hall and were originally to hold the post office. John Inchley was the sub-postmaster in 1905.

STOCKERSTON

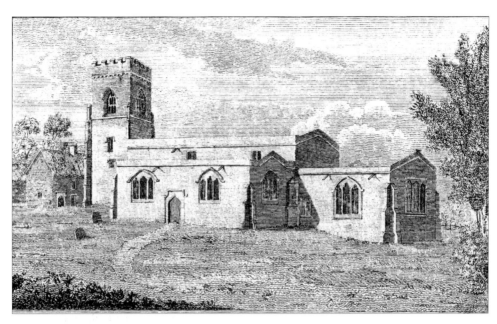

The church of St Peter, Stockerston, south-east view. An engraving published in 1798. The vicar was Revd Robert Boon MA. A late thirteenth-century building with a dated tower and defensive battlements.

St Peter in the trees, Stockerston, September 2006. An extensive restoration took place in the 1880s. There are a good collection of monuments fromt the thirteenth, fifteenth, sixteenth and seventeenth centuries off the south aisle; some were possibly damaged during the reformation.

BLASTON

The two small churches at Blaston have a chequered history.

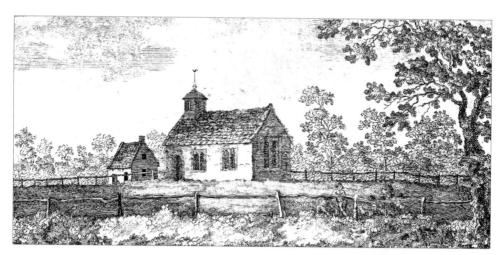

This is the original church of St Giles in 1792. It was demolished and rebuilt by Revd G. C. Fenwicke.

The manor house at Blaston, 1902. The home of Mrs G. Fenwicke, the wife of the late Revd G. C. Fenwicke.

MEDBOURNE

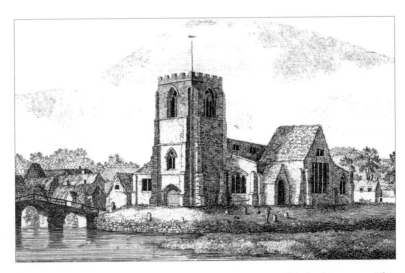

The church of St Giles, Medbourne, an engraving published in 1798. This is an early church. Possibly a Saxon church stood on this site: considerable remains have been found locally. After the Norman Conquest a church was constructed here and certainly demolition and rebuilding took place in the late thirteenth century. Evidence of this incomplete rebuild is still evident, when the engraving printed above is considered.

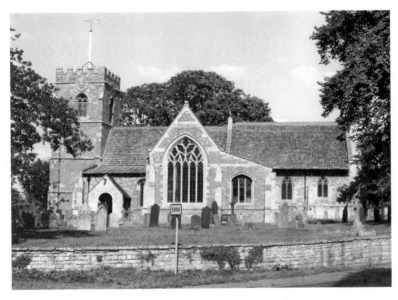

The church of St Giles, September 2006. Extensive rebuilding programmes have taken place in an endeavour to correct past mistakes, commencing in 1876 through to 1880. In the years 1911-12 more restoration took place.

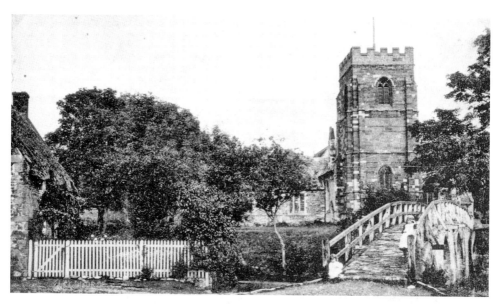

This picturesque bridge straddles the Medbourne Brook near the church of St Giles 1905. The brook rises in Cranoe, Tugby, Hallaton and Horninghold, and feeds into the River Welland just south of the village. Medbourne parish is on the line of a Bronze Age road, obviously connected with the iron-ore excavations of nearby Hallaton.

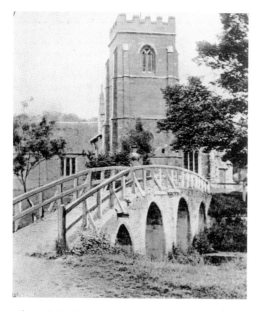

Above left: A view of the packhorse bridge at Medbourne, 1902. On Friday 3 April 1646 this site was the scene of a desperate battle between the villagers and an organised troop of Parliamentarian soldiers. The parson had arrested one of the troop and held him in the church. It is thought the Medbourne Brook had been damned, so filling the moat with water, to form a defendable island.

Above right: Revd Charles Fryer Eastburn MA, 1902, vicar at the church of St Giles, Medbourne.

The Nevill Arms, Waterfall Way, Medbourne, September 2006. In 1846 the lord of the manor of Medbourne was Charles Nevill Esq. The licensee of the Nevill Arms was Benjamin Payne.

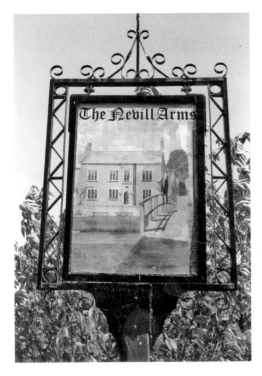

This photograph of the inn sign hanging in front of the Nevill Arms indicates the footbridge and ford across the Medbourne Brook. Medbourne is a picturesque village near the River Welland. When visiting this district, visit some of the very pleasant public houses and enjoy the food and drink that these hostelries offer.

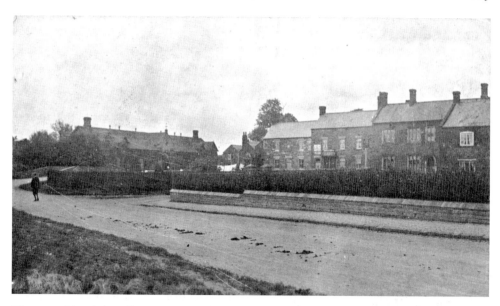

The west side of the village green, Medbourne in the 1920s. This village suffered badly at the end of the English Civil War. On 3 April 1646 ten parliamentarian troopers entered the village bent on plunder, fairly certainly along the road indicated above. The villagers resisted and fought the looters off. The parson arrested one and locked him in the church. This building was easily defended because the local stream acted as a moat. The looters retreated and returned with twenty cavalrymen. The locals were no match to the professionals; many were killed, not least of all the parson's servant, who 'had his bowels let out with wound'. The Parliamentarians sacked the village, driving off all of the village cattle.

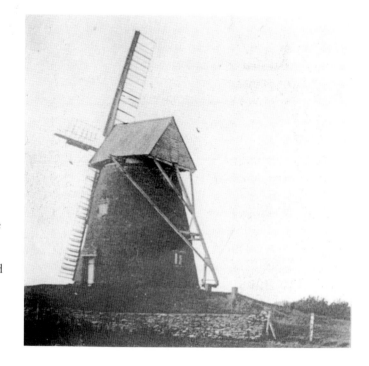

Medbourne Windmill, *c.* 1900. A tower mill with an unusual cap. The miller in 1891 was John Kirby and by the end of the century he had ceased grinding corn by wind, then using steam power. This interesting mill was demolished in January 1902.

NEVILL HOLT

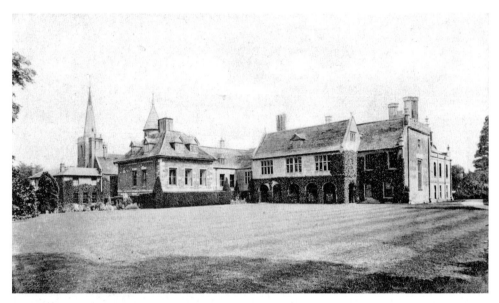

The church of St Mary, 'Holt', 1905, incorporated into the hall, owned by Sir Bache Cunard Bt. JP.

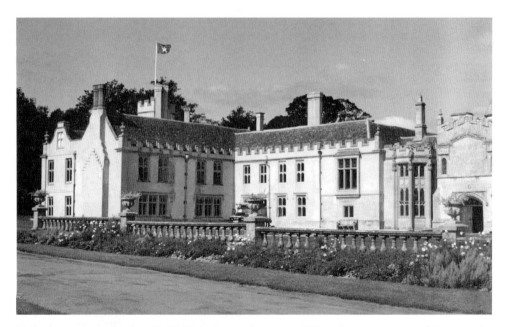

The preparatory school at Nevill Holt, September 2006. When the estate was sold in 1919 the hall was purchased by Revd C. A. C. Bowler; he converted it into a school. He was master in charge at the lower school at Uppingham. The hall was built in the late fourteenth century. The flag is flying above King John's Tower.

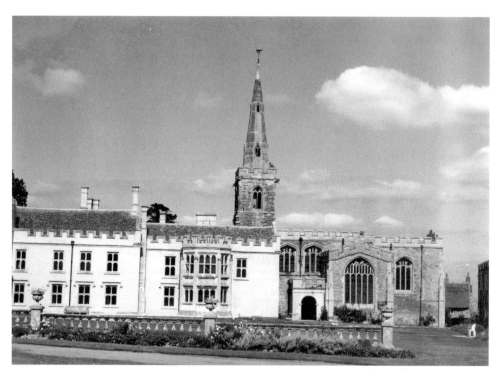

The preparatory school is incorporated into the church of St Mary, September 2006. The church is late thirteenth-century, containing a Norman font. In the south transept there is an alabaster tomb chest with the recumbent effigy of Sir Thomas Nevill, 1636.

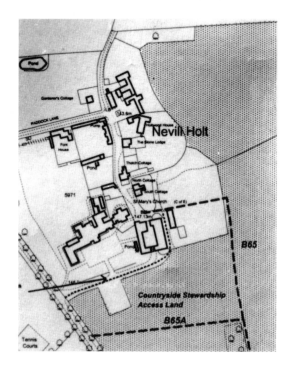

Nevill Holt, the village plan, indicating the school, church, and 'the stables'. Cottages and lodges are clearly listed.

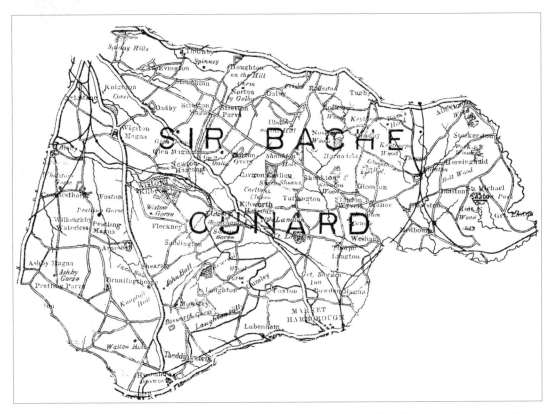

A map of the Billesdon Hunt under the direction of Sir Bache Cunard Bt. JP in 1883. Holt wood is indicated to the east of the map.

CREATION 1859.

CUNARD, Sir Bache Edward. Third Baronet. Eldest son of Sir Edward, Second Baronet, by Mary, daughter of Bache McEvers, Esq., of New York, merchant. Born May 15th, 1851; succeeded his father in 1869. Master of the Billesdon Hunt in 1878; is a Magistrate for Leicestershire. Married, 1895, Maude, daughter of the late E. F. Burke, Esq., of New York.

HEIR PRESUMPTIVE—His brother, Gordon. Born May 22nd, 1857. Married 1889, Edith Mary, daughter of the late Col. J. S. Howard. Residence, Thorpe Lubenham, Market Harborough.

By Perseverance.

RESIDENCE—Nevill Holt, near Market Harborough.
CLUB—Turf.

The First Baronet, Sir Samuel, established the Cunard Line of Mail Steamers between the United States of America and England.

Above left: Sir Bache Cunard Bt. JP living at Nevill Holt Hall, 1906. His grandfather founded the Cunard Line. He was Master of Foxhounds of the Billesdon Hunt, 1878-88, eventually to be named The Fernie.

Above right: The *Cunard record*.

DRAYTON

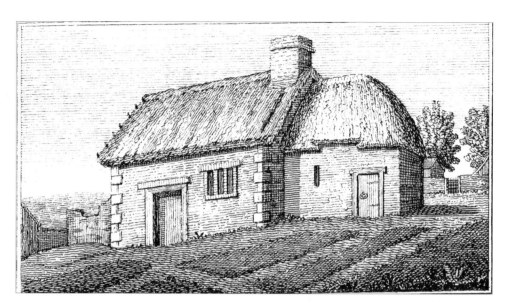

The chapelry of St James at Drayton, drawn and engraved by Longmate in 1794. Built in the early part of the twelfth century, it was a Norman church possibly constructed to satisfy the local Christian Saxons.

St James'
at Drayton,
September
2006. During
the eighteenth
century this
small church,
the smallest in
Leicestershire,
fell into
disrepair. It went
out of use until it
was rebuilt in the
years 1878-79. A
one-cell church/
chapel!

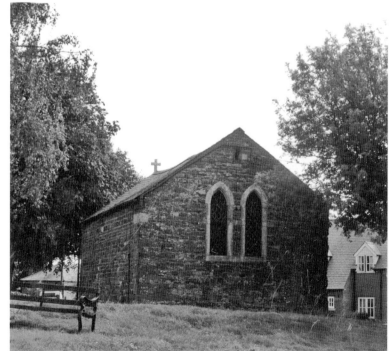

BRINGHURST

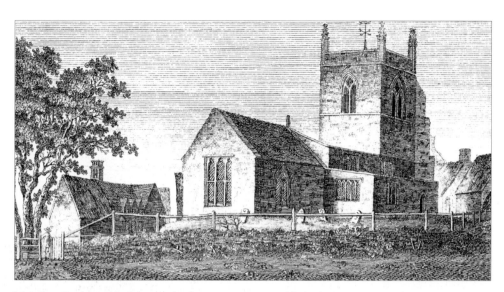

The church of St Nicholas, Bringhurst; an engraving published in 1798. An early Norman church with a reasonable amount of thirteenth-century carved design.

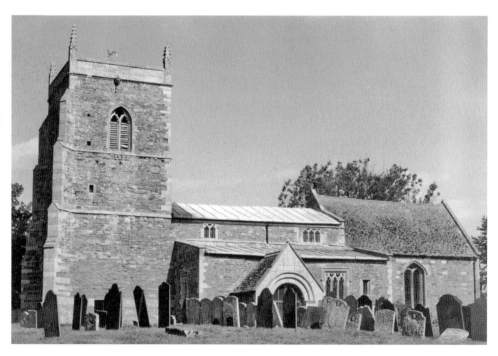

The church of St Nicholas, Bringhurst, September 2006. A strongly-built squat tower, the base is early Norman. The top of the tower is late thirteenth-century. The Victorians restored the interior in the years 1862-3.

GREAT EASTON

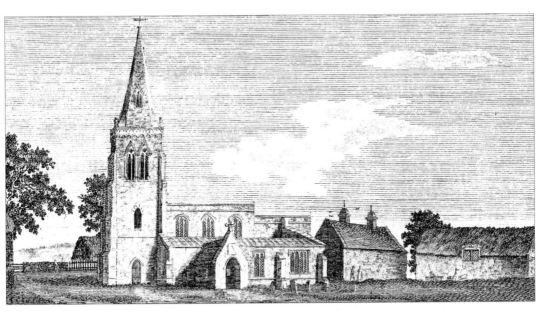

The church of St Andrew, Great Easton, viewed from the south. An engraving published in 1798. A Norman church with Norman carving in evidence.

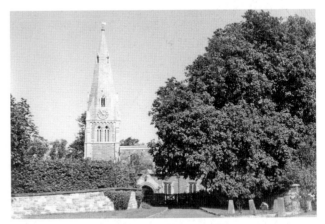

Above left: An important silver paten held at the church of St Andrew, dated 1350. In 1890 it was considered to be the oldest piece of church plate held in Leicestershire. Weighing 1.5 ozs, in the centre of the paten is an engraving of the head of Christ. *Right:* The church of St Andrew today.

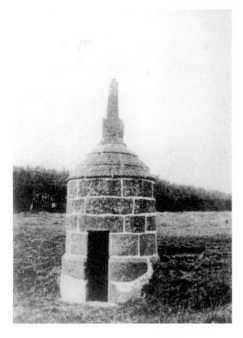

A photograph of 'The Roman Well' standing in a field north of the church in 1910. Possibly part of a long-lost farming community.

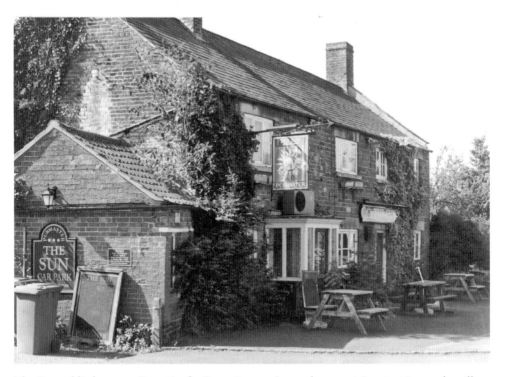

The Sun public house, 6 Cross Bank, Great Easton, September 2006. In 1846 it was the village of Easton Magna; the licensee at the Sun Inn was John Osborn. In 1880 the village was Great Easton. The Sun Inn was now run by John Claypole; he was also the village butcher. In 1900 the licensee of the Sun was Alfred Bosworth. In 1905 the landlord was Edward Brudenell.

A drawing of Crested Grebes on Eye Brook reservoir drawn by Jack Badcock in 1972. The author enjoyed many walks with Jack around the canals, rivers and this reservoir in the 1970s. His knowledge of the history of this part of Leicestershire was extensive. He linked man's changes in the countryside with nature and the alteration to the countryside he had witnessed during his lifetime.

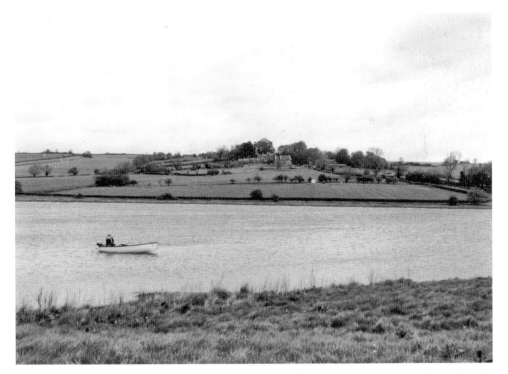

A view of Eye Brook reservoir near Great Easton, 2002; on the far bank is the village of Stoke Dry in Rutland. During numerous moonlit nights in April 1943 the valley vibrated to the noise of Lancaster bombers practising for the daring bombing raids on the dams in Germany in May, sights being taken across the surface water to line up with the dam wall.

CONCLUSION

Above left: The Battle of Naseby, an engraving published in 1830.

Above right: The memorial erected near the site of the Battle of Naseby, south of Market Harborough in 1823.

Numerous books have been published dealing with the modern town of Market Harborough, when it was little more than a collection of houses at a river crossing. Few authors consider one of the most important events in the history of England took place a few miles south of the town – the Battle of Naseby, a battle that changed the course of English history. The first encounter involving the town took place on 8 September 1642. This Parliamentary town was plundered by Prince Rupert on behalf of the King. Unfortunately his troops consumed too much wine and, as they left the town, the Earl of Stamford was in ambush with 800 Parliamentary cavalry. Rupert was lucky to escape with his life, losing all of the booty.

In January 1645 Sir Marmaduke Langdale charged through the town on his way to the Royalist stronghold at Belvoir Castle, in preparation for the battle at Melton Mowbray, which the Royalists won.

On 11 June 1645 King Charles I stayed overnight at Wistow Hall as the guest of Richard Halford. He rode through the town prior to the terrible battle at Naseby. On retreating from the battle, surviving Royalists occupied the town on 13 June; the Roundheads caught up with the defeated army; 500 prisoners were taken and over 400 Royalists were killed in the town and along the road to Leicester. Charles I escaped to Wistow, on his way to Oxford.